The BOOK OF KELLS
and The Art of Illumination

An exhibition under the Patronage of

Mary McAleese
President of Ireland

Sir William Deane AC KBE
Governor-General of Australia

■ national gallery of **australia**

Produced by the Publications Department
of the National Gallery of Australia, Canberra
Edited by Pauline Green
Designed by Kirsty Morrison
Colour separations by ColourboxDigital, Perth
Printed in Australia by Lamb Print, Perth

Cataloguing-in-publication data
The Book of Kells and the art of illumination
Bibliography.
ISBN 0 642 54164 7.
1. Bible. N.T. Mark -Illustrations. 2. Book of Kells -
Illustrations. 3. Illumination of books and manuscripts -
Australia - Exhibitions. 4. Illumination of books and
manuscripts - New Zealand - Exhibitions. I. National
Gallery of Australia
704.9484074

Distributed in Australia by:
Thames and Hudson
11 Central Boulevard, Business Park, Port Melbourne,
Victoria, 3207

Distributed in the United Kingdom by:
Thames and Hudson
30–34 Bloomsbury Street, London, WC1B 3QP

Distributed in the United States of America by:
University of Washington Press
1326 Fifth Avenue, Ste. 555, Seattle, WA 98101-2604

THE BOOK OF KELLS
and The Art of Illumination

National Gallery of Australia, Canberra
25 February – 7 May 2000

CONTENTS

FOREWORDS

The Honourable John Howard MP,
Prime Minister of Australia

The relationship between Ireland and Australia is a long and splendid one. The contribution of the Irish people to Australia has been one of the central factors in the development of this country.

We are delighted to welcome An Taoiseach, Bertie Ahern TD, on a state visit to Australia. We are most appreciative of the decision of the Government of Ireland to allow the temporary export of a volume of the great Irish treasure, the Book of Kells, to our National Gallery in Canberra.

It has been especially rewarding that the loan of the Book of Kells has prompted the National Gallery of Australia to invite Emeritus Professor Margaret Manion (IBVM) AO to curate the accompanying exhibition of the very best illuminated manuscripts from collections in Australia and New Zealand.

For many centuries, the painted page was one of the most vital art forms in Europe. In this digital age, it is a pleasure to celebrate the great art of the book. We warmly welcome the Book of Kells to Australia.

John Howard

Mr Bertie Ahern TD,
An Taoiseach

I am delighted on behalf of the Government of Ireland to have been able to facilitate the loan to the National Gallery of Australia of the Gospel of St Mark from the Book of Kells. I congratulate Trinity College Dublin and the National Gallery on their efforts to celebrate the warm and close relationship between Ireland and Australia.

The dedicated monks who prepared the Book of Kells around AD 800 were part of a great cultural movement of scholars, artists and travellers. The pigments for the Book of Kells attest to the Irish monks seeking the best materials, such as *lapis lazuli* found in the hills around the Himalayas. The Book of Kells is a truly remarkable manuscript, Ireland's greatest medieval treasure, and I am delighted that the people of Australia will have the opportunity to see it on Australian soil.

Bertie Ahern

Dr Thomas N. Mitchell,
Provost of Trinity College, Dublin

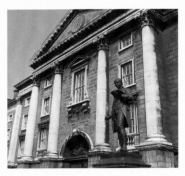

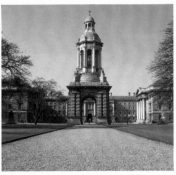

Trinity College is enormously proud of the privilege and responsibility it holds in having care of the Book of Kells. The manuscript, the creation of a ninth-century community of the order of St Colum Cille, is a lasting symbol of the unique contribution made by the Irish to the development of the history and culture of Western Europe. The richness, vitality and beauty of the illustration, together with the dedication and craft of its execution combine to create a breathtaking work of art. It is therefore highly appropriate that a volume of the manuscript be on exhibition in an institution dedicated to the visual arts of the distinction of the National Gallery of Australia. The contribution of many Irish men and women to the cultural, economic and social development of Australia, while less ancient, has been no less significant. The opportunity to mark these contributions in both continents in this millennial year, through the exhibition *The Book of Kells and The Art of Illumination* is one which I hope many Australians will enjoy and treasure.

Thomas N. Mitchell

Trinity College, Dublin: West Front with Oliver Goldsmith statue; Front Square; Trinity College Library

PREFACE

Dr Brian Kennedy, Director, National Gallery of Australia

Some thirty-eight per cent of Australians claim Irish ancestry, making Australia, percentage-wise, the most Irish of countries outside Ireland itself. It is a great honour to be the Irish-born Director of the National Gallery of Australia when the greatest Irish treasure, the Book of Kells, is received on loan for our exhibition *The Book of Kells and The Art of Illumination*. In a spirit of celebration, we bring together the Gospel of St Mark from the 1200-year-old Irish masterpiece with fifty-five illuminated manuscripts from Australian and New Zealand collections.

We are indebted to the Provost and Board of Trinity College, Dublin, for agreeing to the loan of the Book of Kells. The Irish Government has generously approved the loan and we pay tribute to An Taoiseach, Bertie Ahern TD, and to Ministers Síle de Valera TD and Jim McDaid TD. The warm support and patronage of the President of Ireland, Mary McAleese, and the Governor-General of Australia, Sir William Deane, is greatly appreciated.

The loan of the Book of Kells has become the central focus of an exhibition and catalogue due to the efforts of Emeritus Professor Margaret Manion of The University of Melbourne. She is an expert who offers both depth of knowledge and vital enthusiasm. We have had a terrific response to our requests for loans of much loved manuscripts from our colleague institutions in Australia and New Zealand. Our thanks go to all the Directors, Librarians and staff members for their generosity.

The staff of Trinity College have been most supportive colleagues in the organisation of what is a logistically complicated loan. We thank Bill Simpson, Librarian, Robin Adams, Deputy Librarian, Bernard Meehan, Keeper of Manuscripts, and Anthony Cains, Head of Conservation. The staff of the National Gallery of Australia have, as always, worked hard and long, and I thank each one for their commitment to a superb team effort.

An exhibition involving a national treasure is only possible with the assistance of the Federal Government's Art Indemnity Scheme, and we acknowledge with gratitude the support of the Prime Minister of Australia, the Honourable John Howard MP, and Ministers Senator Richard Alston and the Honourable Peter McGauran MP. Our sponsors have also made this exhibition possible. We thank An Bord Fáilte, the Irish Tourist Board; APN News & Media and Independent News & Media PLC; the Seven Network; Aer Lingus; Qantas Airways; Waterford; Guinness Australia; Irish Distillers; Montblanc and Gateway.

Two people have been central to making our hope that we could attract a volume of the Book of Kells become a reality for Australia. They are Colin Steele, University Librarian at the Australian National University, who gave me initial encouragement to pursue the idea, and His Excellency Richard O'Brien, Ambassador of Ireland to Australia, who has been with us every step of the way. In this age of multiple images and endless reproductions, the Book of Kells celebrates the great symbolic value and wonder evoked by a unique artistic object.

Brian Kennedy

CELTIC IRELAND
Brian Kennedy

'... a land of fog and gloom ... beyond it is the Sea of Death, where Hell begins'. When Homer, the celebrated Greek epic poet, wrote these lines in *The Iliad* he was referring to the entire north-west tip of the European land mass. We often think that Australia is a land removed, far away from elsewhere, but this is how Ireland must have appeared in the ninth century BC. The Romans later called Ireland 'Hibernia', from the Latin for winter. The view of Ireland from the Mediterranean was as the 'winter land' of Europe.

The earliest detailed description of Ireland was written after AD 100 by the Greek geographer of Alexandria, Ptolemy, who must have gathered intelligence from seafarers because he lists some fifteen rivers on the island. Ptolemy refers to people he called the Érainn, who were a major tribe in the south of Ireland, Munster. The Greek name for Ireland probably derives from these people, Ierne, from the Irish word for Ireland 'Ériú' (which later became Éire).

Ireland may well be seen today as a Celtic country, but the Celts arrived in slow waves after 500 BC, following the Mesolithic and Neolithic peoples before them. Originally from eastern Europe, by the time they arrived in Ireland, the Celts were already scattered throughout the European continent. By about AD 400, the dawn of the Christian era, we can begin to speak of Celtic Ireland.

The earliest date of human settlement, some ten thousand years ago, makes Ireland relatively young in anthropological terms. The Mesolithic people, the first Irish men and women, probably arriving through northern England, were simple scavengers, living by hunting and fishing. They seem to have settled in the north of the country and in the midlands. The Neolithic people were the first farmers, and their legacy is to be found throughout Ireland in many hundreds of stone tombs, or 'court-cairns', basic burial chambers designed for communal burial. But it is to the north side of the River Boyne Valley in County Meath that the most spectacular tombs are to be found, dating from about 3200 BC, earlier than the great Egyptian pyramids. The tomb complex at Dowth, Knowth and Newgrange is extraordinary. It demonstrates highly developed engineering skills because the tombs' masses of stone could not have been moved easily. The tomb at Newgrange is aligned with the first rays of the morning sun of the winter solstice, which shine through a carefully calculated box in the roof, allowing the sun to creep down an eighteen-metre long shaft and light a sacred place in the secret internal mound. Religious motivation must have been at the heart of it. The Irish seem continually to have developed both religious and secular structures to govern their behaviour.

Bronze working came to Ireland around 2000 BC, and many excellent examples of axes, halberds and other utensils attest the prowess soon achieved in metalwork. Gold seems to have been plentiful, panned in streams in the Wicklow mountains, and gold ornaments of great beauty were made. One thousand years later, the Iron Age began in Europe, but it was not until after 500 BC that it appeared

in Ireland. The Irish of the time have left us their stories, annals, sagas and law tracts, courtesy of the transcription of oral lore by Irish monks from the seventh century onwards. In some of these, echoes of the pagan past may be heard.

Celtic Ireland was a highly stratified society. There were twenty-seven different classes of free men. Slavery was an essential part of society, although we do not know how prevalent. The 'cumal', the price of a female slave, was one of the basic units of value in the exchange economy. Wealth as well as birth secured one's place in society but, unlike other major peoples of Europe, the Celts did not use the principle of primogeniture. The first-born son had no prior rights, and succession to kingship was, theoretically, by any male relative who shared the same great-grandfather. This allowed succession by brothers, nephews, first and second cousins, in addition to the king's own immediate family, and made for considerable instability.

The country was divided into a large number of autonomous 'tuatha' (peoples), small communities, each with its own 'rí' (king). It was common in some 'tuatha' for a successor (or 'tánaiste') to be nominated during a king's lifetime. Amongst the most powerful people in Celtic society were 'brehons', who both promulgated and interpreted the laws. These lawyers trained for years, memorising endless legalities. The law applied to all, even to kings, and the 'brehons' led the intellectual élite. The other learned people were the druids, the priests of pagan Celtic society. The festivals of the seasons were marked by regulated rituals and the druids also served as prophets. It was a harsh masculine world of violence, retribution and internal dissension, a land the Romans had not thought worth conquering. Some Irish fought in the Roman armies, however, and there is considerable evidence of trade between Ireland and Roman Britain.

'Filí' (poets) were significant in Celtic life, and their position was to write praise-verses for their kings and to satirise their enemies. One ancient law tract tells us that a master poet or 'file' was entitled to travel with a retinue of twenty-four servants. Their poetry was remarkably free, often sexually explicit, and capable of showing the lineage of their kings as far back as the fabled Great Flood.

It was into this Celtic Ireland, a small island with no towns or capital, a culture not a state, that Christianity had arrived by the fifth century. Prosper of Aquitaine, a contemporary chronicler, wrote in his annal for the year 431: 'Palladius, consecrated by Pope Celestine, is sent as their bishop to the Irish believing in Christ'. We know little of Palladius and he has long been overshadowed by Patrick who, although Ireland's national saint with his feast celebrated on 17 March, was a Briton.

Patrick is probably a compendium of characters, as so much is attributed to him throughout Ireland. He did not remove the snakes from Ireland. The absence of snakes had been noted by the Roman geographer Solinus in the third century. The beautiful hymn known as 'St Patrick's Breastplate' was written after his lifetime. He is unlikely to have driven a chariot three times over the body of his sister Lupait to punish her for fornication. That story first appears in the ninth century. It is first said as late as the seventeenth century that Patrick used the leaves of the shamrock to explain the mystery of the Holy Trinity, three persons in One God.

Despite all this, we have two very early texts attributed to Patrick himself, the 'Epistola' (or Letter) and the 'Confessio' (or Declaration). In his letter, Patrick denounced the troops of a leader called Coroticus, who had massacred converts to Christianity. In the 'Confessio', Patrick told his own life story and justified himself in answer to his critics. He wrote in Latin, but was poorly educated. His grandfather was a priest and his father a deacon. Clerical celibacy, although praised, was not widely enforced in the early British Church. When he was sixteen, Patrick was carried off, most likely from Wales, by Irish raiders who sent him into slavery in the west of Ireland. After six years he escaped and, enduring much hardship and time spent in Gaul (France), he returned to his family. In the most significant of many dreams, he was called by God to convert the Irish. He was asked to be 'The Voice of the Irish'. 'We beg you, holy boy, to come and walk among us again.'

Throughout the fifth and sixth centuries, 'tuath' by 'tuath', Ireland was evangelised. The dioceses of the first bishops were established coterminous with the 'tuatha'. There were no cathedrals and there was no clerical bureaucracy. Bishops had authority over priests and churches and could own land, but only when they were part of the established 'fine' or kinship group. In contrast, monks, who were not permitted to conduct baptisms or to receive alms, established monasteries which were more like the family structures of kinship and allowed local authorities to retain control over lands.

Christianity adapted in Ireland to the pantheistic indigenous religion and subsumed pagan feasts. The Feast of All Saints, celebrated on 1 November, was on the same day as the Celtic harvest festival of 'Samhain'. By about 600, Ireland was a rudimentary Christian society, a conquest achieved apparently without martyrs, and producing endless numbers of saints.

There was another form of martyrdom which was much practised, the so-called 'white martyrdom' of voluntary exile in self-denial and emulation of St Patrick which led hundreds of monks to sail abroad to found monastic sites all over Europe, Irish 'peregrini pro Christo' (pilgrims for Christ). One of these exiles for Christ was Colum Cille, later known as St Columba, who was born in 521 or 522, of the ruling family of Tir Conaill, now Donegal. He studied scripture under the bishop Finnian, and went into exile, certainly by 574, on the tiny, remote Hebridean isle of Iona off the west coast of Scotland. On this island of only 800 hectares, he established a monastery and, from Iona, missions were launched on the neighbouring small islands and on the Irish and British mainlands. Adomnán, who in the late seventh century was ninth abbot of Iona and a member of Columba's family, has left us a richly detailed life of the saint. On Iona, ten of the twelve abbots up to 724 were of the same kin as Columba. They were celibate and had taken orders, but subsequently abbots were often effectively lay lords, increasingly married, and sought to pass succession to their sons.

The story of Celtic Christianity is one of great faith and sainthood and yet severe faction fighting, thus only partly a reputed 'Land of Saints and Scholars'. Monasteries occasionally even went to war with each other. The most notorious instance was in 764 when Clonmacnois and Durrow fought, and reportedly two hundred members of the Durrow 'familia' were killed. The growth of the monastic movement brought power. Throughout the sixth century many of the most famous monasteries were established, Clonard by 515, Clonmacnois (the largest) about 555, and Clonfert about 560. St Columba had established

monasteries at Derry in 546 and Durrow about ten years later, that is before he left for Iona. From there, he and his successors created a great network of parishes ('parochiae') from Kells to Lindisfarne, perhaps ninety in all. He died in his seventy-fifth year on Saturday 8 June 597, while praying in the community church on Iona.

St Columba seems to have had training as a poet, although many poems given to his hand are falsely attributed. The famous 'Amra Choluim Cille' ('The Song of Colum Cille'), composed on the saint's death by Dallán Forgaill, is amongst the oldest verses of vernacular poetry in Europe. The Irish monks valued learning. As part of their mission, they brought a love of books, writing and storytelling. Early Celtic society had been illiterate except for a monumental form of script called 'ogham', where different lines represented the characters of a primitive alphabet. The Irish took to the art of the book with exemplary fervour. The larger monasteries established 'scriptoria' where manuscript production was a specialised practice. Lives of the saints, sagas of voyages across the seas, and new versions of myths, fables and legends were written in Irish. Lyric poetry was created in an Irish form which celebrated love of God by rejoicing in the natural world. Metalwork displayed the technical prowess of Irish craftsmen, and intricate stone crosses revealed the skill of sculptors. It was the growing wealth of the monasteries which propelled artistic achievement, the Golden Age of Irish Art.

The Book of Durrow and the Book of Kells, both now held in Trinity College, Dublin, represent the high point of achievement in manuscript illumination. The Ardagh and Derrynaflan chalices, and the Tara Brooch, all in the National Museum of Ireland, are great treasures of Irish metalwork. Geometrical perfection, elaborate ornamentation, interlacing and filigree, spiralling and step or key patterns, became the staples of an extraordinary output of excellence unsurpassed anywhere else in Europe at the time.

The wealth of the monasteries, internal faction fighting and struggles for succession weakened the Celtic Church, but it was the raids of the pagan Vikings beginning in 795 which fractured the relatively quarantined society. The Vikings were from Norway, intrepid pirates in search of booty. They attacked the wealthiest section of the Celtic community, the Church, and their raiding became ever more intense throughout the ninth century. Iona was raided in 795 and 802, and again in 806 when sixty-eight members of the community were killed. This caused the relics of St Colum Cille to be removed and taken to safety in Ireland. A new monastery was constructed at Kells, seventy kilometres north-west of Dublin, and some of the relics of the saint were placed in the community church there. The most important treasure of the house became known as the Book of Kells.

The Viking raids must have been terrifying. The great ships, with their fierce-looking bowsprits of animal heads, seemed to appear everywhere from nowhere. Even off the south west Kerry coast, on the small rock island of Skellig, the community of hermits was raided by Vikings in 824. In 827, the Irish annals recorded a fleet of sixty Viking longships on the river Boyne and another on the Liffey. A fleet of one hundred and twenty ships appeared in 849. The Vikings plundered the ancient tombs of Dowth, Knowth and Newgrange in 863, travelling up the River Boyne. The Church in Ireland nonetheless continued to be very influential and, as with previous peoples who came to Ireland, the Vikings began to stay and make

their own communities. In 840 a fleet wintered on Lough Neagh, the country's largest lake. The following year, the future capital of Ireland, Dublin, was founded by the Vikings at the mouth of the River Liffey. The Irish began to accommodate the Vikings, negotiating settlements, and gradually assimilating them.

By 980 there is evidence that some Vikings had converted to Christianity, for in that year Olaf Cuarán, King of Dublin, died while on a pilgrimage on the isle of Iona. In 1007, we have the first written account of the Book of Kells recorded in the Annals of Ulster:

> 'The Great Gospel of Colum Cille was wickedly stolen by night from the western sacristy in the great stone church of Cenannas [Kells]. It was the most precious object of the western world on account of the human ornamentation. This Gospel was recovered after two months and twenty nights, its gold having been taken off it and with a sod over it.'

At the dawn of the first millennium, the Golden Age of Irish Art had come to an end. The Book of Kells was saved, and since about 1653 it has been cared for and made available for public viewing by Trinity College, Dublin. In the year 2000, the dawn of the third millennium, the Book of Kells finds temporary home in Australia.

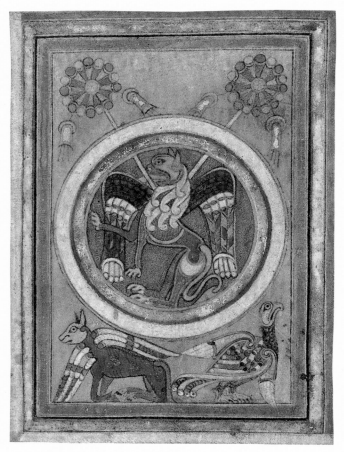

Detail from fol. 129v, *Book of Kells*

THE BOOK OF KELLS AND THE ART OF ILLUMINATION

INTRODUCTION
Margaret Manion

The exhibition in the National Gallery of Australia of a volume of the Book of Kells, one of the great masterpieces of western art, is an important cultural event on several counts. Throughout the centuries, the pages of this great Gospel book have aroused wonder and admiration at the ingenuity and creativity of the human spirit. Moreover, the story of the book's survival for over twelve hundred years, makes it all the more precious. Not only does the Book of Kells testify to the vitality of Celtic art in the Early Middle Ages, but its fortunes also reflect the turbulent nature of the period in which it was created. This was an age in which the British Isles were ravaged by Viking raids, and monastic settlements, the cultural heart of the country, uprooted. Yet, against these odds, the Book of Kells survived. In later times it suffered further disturbances, and in the middle of the seventeenth century, during Ireland's battles with Cromwell, it was transferred from the ruined parish of Kells to Trinity College, Dublin, where ever since it has had a secure and distinguished home. Thanks to the generosity of Trinity College and the collaborative support of the Irish and Australian governments, a volume of the Book of Kells has come to Australia, for a brief while, and residents of this country have the unique opportunity of engaging directly with this masterpiece.

The hosting of the Book of Kells in the year 2000 is especially felicitous, and offers the opportunity to present this work from a particular historical perspective. Although the precise date of the birth of Christ remains the subject of scholarly debate, the year 2000 marks two millennia of Christianity in the western calendar. In this memorable year, the illuminated Gospel book, *par excellence*, provides an ideal focus for reflection on the stimulus provided to artistic expression, throughout the centuries, by one of the great world religions.

The Book of Kells also highlights another significant cultural phenomenon whose origins go back to the first century of the Christian era, namely the handwritten book in codex form, and its embellishment or illumination. Examples of the illustrated codex survive from as early as the fifth century, and under Charlemagne, in the ninth century, classical elements were integrated into the tradition of western book illumination. Above all, however, it was in the great Insular Gospel books of the seventh to the ninth centuries that the initials and letters of the script itself became the major focus for ornamentation. Thus, those bonds were forged between art and text which were developed in so many inventive ways during the lifetime of the handwritten book. The Book of Kells represents the peak of Insular illumination, a period in which the decorative vocabulary of Celtic art, developed over many thousands of years to adorn metalwork and stonework, was adapted by artists to express the beliefs and concepts of Christianity in the art of manuscript painting.

The present exhibition focuses on the Book of Kells from this dual perspective: its powerful artistic expression of the Christian faith, and its place in the history of the illuminated manuscript, which flourished until the sixteenth century and the advent of printing. To this end, in addition to the Gospel of St Mark from the Book of Kells, the exhibition encompasses a selection of the medieval and Renaissance manuscripts in Australian and New Zealand collections which demonstrate the legacy of Kells throughout the centuries, both in terms of Gospel illustration and of the illuminated book.

As a prelude to the discussion of the illumination of the Book of Kells in the following pages, it may be helpful to comment here on the significant place of the Gospels in the Christian religion, and on the reasons why elaborately decorated Gospel books came to be used, at an early stage, in the liturgy or public worship of the Church.

Scholars generally agree that the four Gospels, adopted by the Christian Church as canonical, were written between AD 60 and 100. They record the life and teachings of Christ and reflect an oral tradition that goes back to the lifetime of the apostles who shared in his work and mission. The writers of the Gospels — the evangelists, Matthew, Mark, Luke and John — are directly associated with this apostolic tradition. Matthew and John were apostles themselves, Mark was the disciple of Peter, and Luke the disciple of Paul. Even more importantly, the Gospels were interpreted by the Early Christian community not simply as a record of the life and deeds of their founder but as an expression of faith in the mystery of the Incarnation, handed down by personal witnesses of the life and redemptive death of Christ.

It was in this spirit that the Gospels were regularly proclaimed in the Eucharist or Mass. From very early times, this celebration of praise and thanksgiving had an apocalyptic as well as a commemorative dimension, since the life of Christ was seen to culminate in his victory over death and his return to the glory of the Father in the heavenly Jerusalem, as described in the Apocalypse or Book of Revelation in the New Testament. As early as AD 170, Irenaeus, one of the Fathers of the Church, identified the writers of the Gospels with the description in the Apocalypse of the four living creatures or animals that surround the throne of God:

> In the centre, grouped round the throne itself, were four animals with many eyes, in front and behind. The first animal was like a lion, the second like a bull, the third animal had a human face, and the fourth animal was like a flying eagle. Each of the four animals had six wings and had eyes all the way round as well as inside: and day and night they never stopped singing: 'Holy, Holy, Holy is the Lord God, the Almighty; he was, he is and he is to come'. (Apocalypse 4. 6–8)

This description is based, in turn, on the visions of the Old Testament prophets Ezekiel (1. 4–11) and Isaiah (6. 2–3), and although the Apocalypse was not accepted as canonical by the Greek Church, Irenaeus' identification of the evangelists with the four animals came to be universally acknowledged. Apse mosaics of Early Christian churches in Rome and Ravenna show Christ enthroned in majesty,

in the company of angels and saints, while, on the triumphal arch leading into the sanctuary, the four animals, bearing Gospel books in their claws or talons, offer him homage. The earliest surviving illuminated Gospel books are contemporary with these mosaics, and their decoration, in similar fashion, combines reference to the historical past with celebration of an eternal present.

This is the context in which the decoration of the Book of Kells is to be understood. The four animals recur again and again. As symbols of the evangelists, they testify to the authenticity of the Gospels and the link with apostolic tradition. At the same time they symbolise the inspired and visionary nature of these sacred writings, whose message is that the divine and human are met in Christ.

In more general terms, the Book of Kells also indicates the far-reaching consequences of the doctrine of the Incarnation for the relationship of Christianity to the visual arts. Belief that the splendour of the Godhead was revealed in Christ made it acceptable, indeed beneficial, to express in visually imaginative terms the interrelationship between the heavenly and the earthly, the material and the spiritual. Patterns of wonderful intricacy and enigmatic figures, both human and animal, invade the pages of the sacred text, as though to emphasise its mysteries and to express the paradox of the interconnectedness of things secular and religious. Figurative compositions — evangelists' portraits, Christ in Majesty, Mary and the Christ Child, and selected Gospel scenes — also reveal the artists of Kells as absorbing influences from their continental and eastern colleagues and adapting them to their own purposes.

The manuscript paintings in this exhibition, drawn from later works that also seek to communicate the message of the Gospels, demonstrate how, over the centuries, artists have continued to express, in a wide range of cultural and stylistic forms, their shared vision of the Incarnation and its implications for the human race.

As a splendid and ancient example of the hand-crafted and embellished book, the frontiers of Kells extend yet further. For many centuries, painting on parchment, in close association with the written word, was a powerful means of artistic expression that attracted both religious and secular patrons, as the books in this exhibition testify. The name given to this kind of painting is illumination, a term which may derive from the fact that the precious metals of gold and silver and the rich and glowing colours often used in such paintings light up the page. Today, however, illumination is used in a generic sense for all manuscript painting. As with more monumental forms of decoration such as frescoes, mosaics or panel painting, illumination developed its own governing artistic principles. These relate directly to the medium of the book, and while the role of the illuminator came in time to be distinguished from that of the scribe, art and text remained intimately linked. Such links are expressed in extraordinarily creative ways in the Book of Kells; and in the illustration and decoration of manuscripts, produced in later ages in very different cultural circumstances, we may still discern its legacy.

THE ART OF ILLUMINATION
Margaret Manion

The key to the art of the illuminated book is the relationship between the written text and its embellishment or decoration, which in this context also includes accompanying illustrations. On the one hand, the Book of Kells exemplifies the principles of manuscript illumination; on the other, its creative profusion defies at every turn the existence of a prescriptive rationale. The dominant impression is one of artistic energy, refreshingly free from predictable restraints, but at the same time expressive of a powerful inner coherence: a fact all the more to be marvelled at when one reflects that this is not the work of one individual — nor of angels, as has been enthusiastically claimed — but of a team of monastic scribe–illuminators.

The Book of Kells and The Art of Illumination enables some of the decorative magic of the Book of Kells to be enjoyed at close quarters. It also presents this extraordinary book in the context of later illuminated manuscripts, many of which are the finest of their kind. They include twelfth-century monastic books from both the east and west, books made by Parisian illuminators for exacting royal and noble patrons in the fourteenth and fifteenth centuries, and books whose ornamentation breathes the elegant classicism of Renaissance Florence in the last phase of illumination before the manuscript yields place to the printed book. While these works help to indicate the unique place of the Book of Kells in the history of the illuminated book, they also attest the richness and variety of that history. As a guide to the viewing of the exhibition from this perspective, a brief outline of the main decorative and design features of manuscript illumination is provided here.

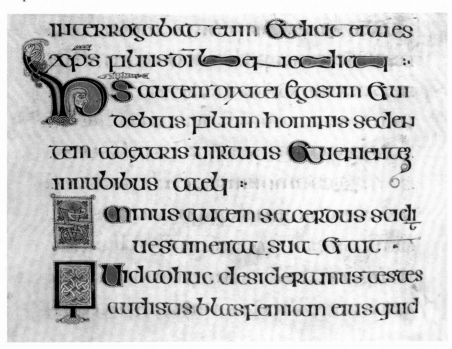

Detail from fol. 179v, *Book of Kells*

Manuscript production — materials and design

All the elements that go into the making of a manuscript have a bearing on its illumination: the material from which the book is made; its overall design; the layout of individual pages; and above all the script. By the ninth century — the time of the appearance of the Book of Kells — the basic techniques and processes of manuscript production were well established and were to change little over the ensuing centuries. The favoured material was parchment, which is made from the skin of animals. In the case of Insular manuscripts, the skin was calf or vellum, whereas on the continent sheep and goat skins were more usual. The word 'vellum', however, is often used interchangeably with 'parchment' to denote the material of medieval manuscripts. The skins, having been processed into smooth sheets of parchment, were then cut into leaves or folios, the size of the desired book; and each double-page opening was carefully ruled, with provision being made for both the script and its proposed decoration. The text space was usually defined within a central frame that left generous margins of plain parchment on all sides. While specialist works might require more complex layouts, this positioning of the text in relation to the margins was to remain a governing principle of book design and to persist into the era of the printed book.

The painting in illuminated manuscripts is firmly underpinned by drawing. In the spaces reserved for decoration, under-drawings were executed, often in considerable detail, before being painted in a range of rich colours or pigments of metal, vegetable and animal origin.

Script and rubrication

The work of the scribe was paramount. Writing was a craft in itself, and specific names and descriptions have come to be attached to the types of script that developed over the ages. This area constitutes a specialisation of its own, called paleography, and there is necessarily a close link between the study of script and its decoration. It was the practice for the scribe to rubricate the text, that is, to mark or annotate in a contrasting colour to the black or brown ink used in the body of the work, headings, divisions and directions for reading the text — for example, in liturgical rituals. Red ink was often used for this purpose, hence the words 'rubric' and 'rubricator'.

Fol. 325r, Cat. No. 22

Decorated and historiated letters

Rubrics, through their colour and the different types of lettering often used, contributed to the decorative ordering of the page; but it was in the singling out of certain letters for ornamental emphasis that decoration and text became dramatically intertwined. Often these letters were capitals and initials that introduced a text or marked important divisions within it; but, as the Book of Kells demonstrates, whole phrases could also be fashioned into introductory panels. Within the body of the text, smaller letters were embellished to highlight sentences, paragraphs or verses.

Letters could be written or ornamented in coloured inks by the scribe, as part of the overall task of rubrication. Alternatively, they were painted after the text had been written, either by the scribe or by an artist–illuminator.

Over the course of the years, ornamented letters have been divided into various descriptive categories by art historians. Two basic terms are used here: 'decorated' refers to initials or letters that are composed largely of decorative motifs, whether they be of abstract linear patterns, of zoomorphic or anthropomorphic motifs, or of more naturalistic foliate and floral design; 'historiated' is reserved for initials with recognisable scenes or figures, though these may be combined to a larger or lesser degree with purely decorative elements.

Line-endings

Space left at the end of a line was ornamented with decorative elements called line-endings. These tended to comprise the same decorative vocabulary as the letters. The practice also obtained in Insular books of continuing a line of text into empty space left in the line above, and to signal this by inserting a decorative 'return' or 'wrap-mark', often in the guise of a sprightly hybrid, human or animal motif.

Detail from fol. 19r, Cat. No. 25

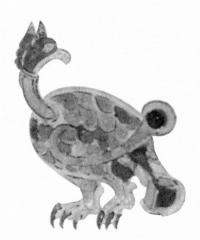

Detail from fol. 182v, *Book of Kells*

Borders

In the thirteenth century, extensions of Gothic initials projected into the margins to form decorative borders and, in the course of the following centuries, borders became a regular part of manuscript illumination. They incorporated the motifs characteristic of the particular period, country or region, and could extend along one or more sides of the page. The horizontal projections of Gothic bar borders served as the platform for scenes and figures of serious or playful intent at the foot of the page (*bas-de-page*). Human figures, grotesques and drolleries sported in the ivy leaf cusps or branches of the border, or were contained along with subsidiary scenes in medallions and lozenges set within the border. Borders could also take the shape of broad bands or panels filled with foliate, floral and other decorative designs.

Miniatures

Independent paintings or miniatures — a term which derives from the red pigment 'minium' used for rubrication, and which does not in this context refer to size — were related to the text, not only through their thematic content, but also by the elements that they shared in common with the decoration of the script and by their integration into the layout of a folio, or a double-page opening.

Sometimes, especially in the early Middle Ages when book production was in the hands of scholar monks, the same person was both scribe and illuminator. In the course of time, however, writing and illumination became separate activities. This was particularly the case from the thirteenth century on, in centres such as Paris, where workshops, or ateliers of artist–illuminators collaborated with scribes and stationers (book dealers) to produce elaborate commissions for institutional patrons, such as the university and the church, and wealthy individuals.

Detail from fol. 41v, Cat. No. 41

Text and decoration in the Book of Kells

The Book of Kells both exemplifies and transcends the conventions of the illuminated manuscript. Its bold script, written on ancient calf-skin, in Insular majuscule, mostly in a brownish iron-gall ink with occasional red rubrics, is accentuated on almost every page by decorated letters, line-endings and wrap-marks. Coloured in green, yellow, purple, red and blue, they comprise a marvellous variety of shapes and motifs that reflect the rich and diverse cultural resources of their makers. Celtic spirals, interlace and key patterns, are combined with animal and human hybrid interweavings, together with more naturalistic figures, foliage, birds and beasts.

Uncannily, the Book of Kells also seems to anticipate later decorative developments in manuscript illumination. The border, for example, which did not emerge as an explicit decorative element until the thirteenth century, appears in embryo on several of the pages of this ninth-century manuscript. Thus, the vertical banding together of decorated initials which introduce the beginning of a series of lines, as in the list of the Beatitudes in Matthew 5. 3–10 (folio 40v), or the account of the genealogy of Christ in Luke (folios 200r–202r), gives the effect of a border panel. Delicate coloured tendrils that escape into the margin from the contours of twisting initials (folios 212r and 242r) also prefigure the decorative border. Likewise, the small figures and animals that gambol or loiter on many of the pages of the Book of Kells, though basically construed as line-endings or wrap-marks, prefigure the Gothic world of the inhabited border and margin.

Large-scale decorated initials and panels of extraordinary intricacy mark introductory sections and significant passages of the Book of Kells. These combine, in certain cases, with full-page figurative illustrations. Missing folios obscure certain aspects of the overall program, and as Bernard Meehan's analysis of the fully decorated and illustrated pages of the Gospel of St Mark demonstrates, there is much about this book that remains enigmatic and mysterious. Nevertheless, the basic intent is clear, and one is left with the overwhelming impression that both scribes and illuminators shared an intimate understanding of the text on which they worked and of its key role in Christian faith and worship.

Detail from fol. 183r, *Book of Kells*

The image of Mary and the Christ Child (folio 7v), together with the portrait of Christ as Divine Ruler (folio 32v), emphasise the human and divine nature of Christ, in accord with ancient Gospel illustration. In like manner, the symbols of the evangelists and their portraits emphasise both the continuity of the apostolic tradition and the inspired visionary nature of the Gospels.

In keeping with long-established tradition, decoration and illustration in the Book of Kells centre around the following elements: the Canon Tables — concordances, which highlight the interrelationship of the contents of the four Gospels and their canonical standing in the Church; the introduction to each Gospel; and certain textual passages which relate to the great temporal seasons of the Church year — Christmas, Lent, Holy Week and Easter.

Perhaps the most distinctive feature of the Book of Kells is its singular expression of artistic freedom. While the principles that will underpin manuscript design and illumination for centuries are discernible on its pages, these have not yet been systematised into repetitive workshop practices. Whether it be a full-page miniature, a panel composed of introductory initials, or the whimsical decoration of letters on a page of text, virtually every illumination is freshly conceived and executed.

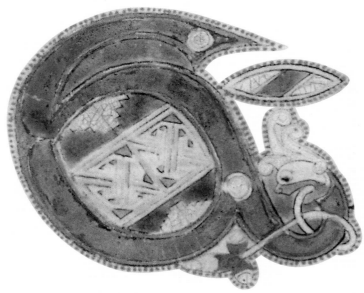

Detail from fol. 182v, *Book of Kells*

The Book of Kells: Word and Image
Bernard Meehan

Like other medieval manuscripts, the Book of Kells can be described in a summary and factual manner. It contains a copy of the four Gospels, with some preliminary texts, and is written in Latin. It was produced, on calfskin vellum, around the year AD 800, by followers of St Colum Cille (died AD 597), either at their monastery on Iona (Argyll, Scotland) or at their monastery of Kells, county Meath, Ireland. It contains 340 folios, numbered 1–339 (folio 36 is used twice; 335, 336 are numbered in reverse order), and was the work of several distinct artists and scribes. Approximately thirty further folios are missing. In 1953 it was repaired and rebound in four volumes. Each folio now measures approximately 33.0 x 25.5 cm.

Missing from this description is the key to the great celebrity of the Book of Kells — its decoration, which has a lavishness and visual impact on a scale that surpasses any other surviving medieval manuscript. On a technical level, the decoration is sophisticated. It is seldom possible for the viewer to focus on a single aspect of any image. Iconographically, the book is complex. There are fully decorated pages with images of Christ, his Virgin Mother, the evangelists and their symbols. Page after page of text combines the transcription of the Gospel with its visual elucidation for an audience which expected to find splendour and colour in a church as well as guidance. Today we have lost the easy familiarity which those in the Middle Ages had with the visual vocabulary and symbolism of the Book of Kells.

St Mark's Gospel

St Mark's Gospel is the shortest of the four Gospel narratives — in the Book of Kells it covers folios 129v–187v from a total of 680 extant leaves — and is usually regarded as the first of the Gospels to have been written. Its author was a member of the Church at Jerusalem, took part in missions with Paul and Barnabas, and appears to have been close to St Peter. According to the Church History written by Eusebius, bishop of Caesarea in the fourth century, Mark's Gospel was composed in accordance with Peter's instructions.

Three openings from St Mark's Gospel have been selected for display at the National Gallery of Australia: folios 129v–130r, folios 179v–180r, and folios 182v–183r.

Book of Kells folios 129v-130r

This opening contains symbols of the four evangelists (folio 129v) and the opening words of St Mark's Gospel (folio 130r). The symbols of the evangelists are prominent throughout the Book of Kells, St Matthew being represented by the Man, St Mark by the Lion, St Luke by the Calf, and St John by the Eagle. The origin of this imagery lies in the prophecy of Ezekiel:

> 'And I saw, and beheld a whirlwind came out of the north: and a great cloud, and a fire ... And in the midst thereof the likeness of four living creatures ... there was the face of a man, and the face of a lion on the right side of all the four: and the face of an ox, on the left side of all the four: and the face of an eagle over all the four ... and their wings were stretched upward: two wings of every one were joined, and two covered their bodies.'
> (Ezekiel 1. 4–11 *passim*)

St Gregory in the sixth century identified the symbols as the four stages in Christ's life: Christ was a Man when he was born, a Calf in his death, a Lion in his Resurrection, and an Eagle in his Ascension to heaven.

On folio 129v, the symbols are arranged around a vibrant yellow cross, each of them enclosed within a prominent yellow circle, perhaps representing a halo. Flabella (liturgical fans), with attachments which may be bells, accompany the symbols — below them in the case of the Man and the Calf, and above them in the case of the other symbols. The Man is accompanied in his frame by another figure (a Man again, or perhaps an angel); the Lion by a Calf and an Eagle; the Calf by an Eagle and what may be, through error, another Calf where a Lion might have been drawn; the Eagle by a Calf and a Lion. The artists seem to stress by this device that the Gospels should be regarded as a unity despite their multiple authorship. It may be significant in this context that the frames containing the symbols are broken in several places. The wing of the Eagle accompanying the Lion intrudes into the frame; the shafts of the flabella in the symbols of the Man and the Calf pass between the yellow circle enclosing the symbol and the inner pink circle; the tail of the Eagle passes outside its circle, though its talons are not shown.

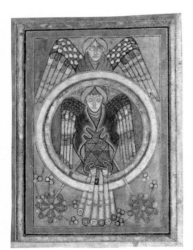

Detail from fol. 129v;
(overleaf) fols 129v-130r *Book of Kells*

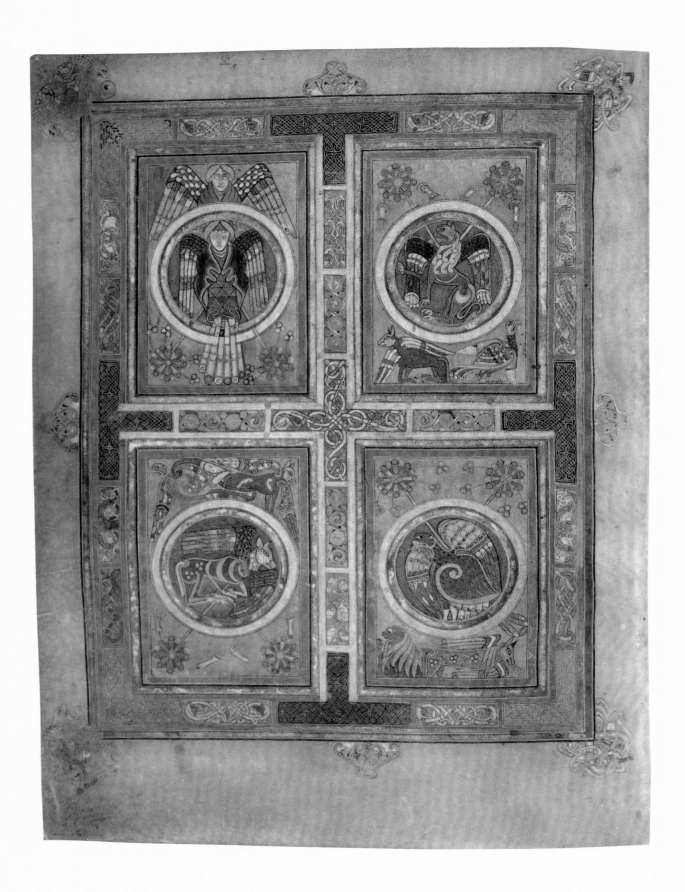

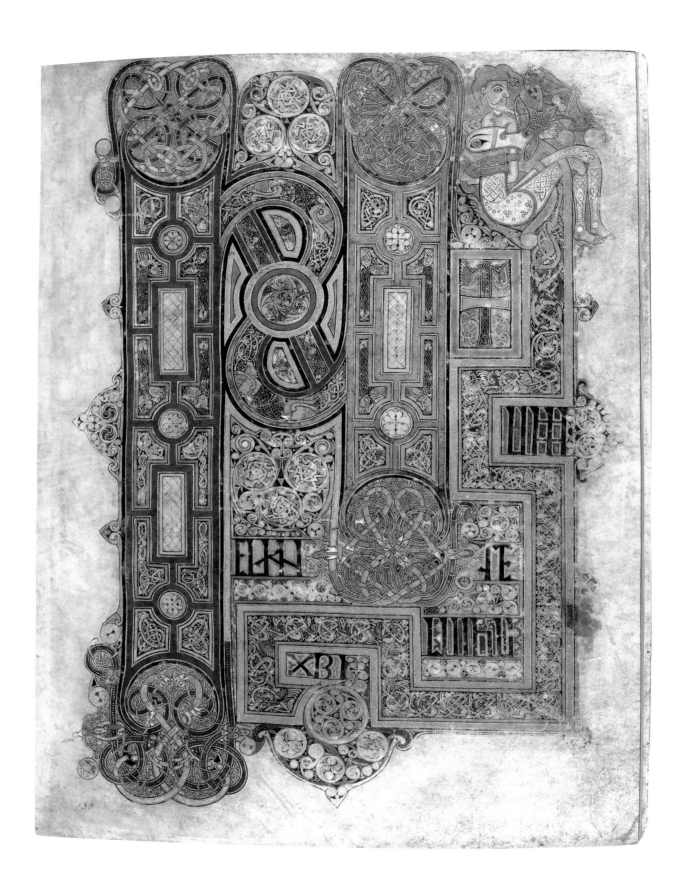

25

Detail from fol. 129v, *Book of Kells*

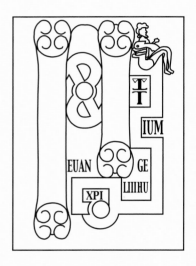

Diagram of fol. 130r, *Book of Kells*

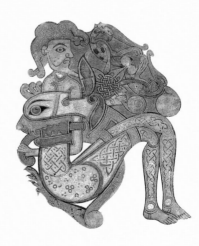

Detail from fol. 130r, *Book of Kells*

As with other major pages of the Book of Kells, the details of folio 129v repay close examination. The outer frame is broken on its left-side corner-pieces to allow zoomorphic interlace, containing addorsing birds (?peacocks) and lions to emerge. Confronting, interlaced birds are added to the other corners. The cross has interlaced snakes at its centre, the snake being a symbol of the Resurrection due to the belief that it renewed its youth when it shed its skin. Two sets of six birds are in panels in its vertical arms. The cross is merged with the outer border at each of its extremities through the use of incredibly fine interlace which is itself shaped into cross formations. There are snakes in panels to the top and tail of the outer border, while its sides contain panels of ornament, two on each side containing snakes, and two with eucharistic chalices from which pairs of birds, entangled in vines, are poised to drink. The corners of the border are filled with fret patterns. The green infill at the top left of the Man is a curious decorative feature of the page. It is not matched elsewhere on the page, and seems to be a later addition.

Folio 130r, facing 129v, contains the opening words to St Mark's Gospel: INIT/IUM EUANGE/LII IESU / CHRISTI , 'The beginning of the Gospel of Jesus Christ ... ' (Mark 1. 1). A highly decorative display script is used, one which poses problems of legibility for today's reader. The diagram (at left) disentangles the letters — the first two of which are greatly enlarged — from the framework of decoration.

At the top right corner of the page, the profile head of a lion, appropriately the symbol of St Mark, bites the full-length figure of a man sitting in the crook of the lion's leg. The man's left hand pulls his own beard, while his right hand clutches the lion's tongue. Iconographically, there is no certainty regarding the significance of this image. It may allude to the passages in Psalms which refer to combat with lions, such as in Psalm 21's: 'They gaped upon me with their mouths, as a ravening and a roaring lion.' The interlace painted in red on the figure's costume is problematic. It can be read as tattooing on a naked body, or as design on a costume, and has even been interpreted as an early example of the Aran stitch which survives to the present day in traditional Irish knitwear.

The decoration of folio 130r is extremely busy, packed with images and symbols for contemplation by those close enough to study the detail of the page. Entanglements of snakes, their heads meeting, are placed prominently at the top and tail of the shafts of the opening two letters. Teeming flocks of birds combine with other creatures in the border which runs down from the figure at top right around to the shaft of the initial 'I'. Pairs of birds appear in the bar of the 'N'. Such birds may be interpreted as peacocks, a common element of the decoration of the manuscript, and again symbolic of the Resurrection of Jesus, due to the belief that the flesh of the peacock did not decay.

Detail from fol. 130r, *Book of Kells*

In the box containing the letters 'IT' there is a pair of what may be griffins. A legendary winged creature, half-eagle, half-lion, the griffin finds a natural place in the symbolism of St Mark's Gospel.

Human figures abound in the decoration of the Book of Kells. Above and below the bar of the 'N' of folio 130r, there are two sets of three roundels containing groups of three men grasping each other's arms. While an allusion to the Trinity may be assumed in this case, much research remains to be done on the significance of such figures in the decoration of the manuscript.

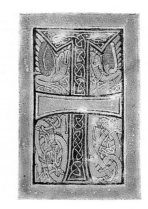

Detail from fol. 130r, *Book of Kells*

As an opening, folios 129v–130r do not have a satisfactory visual balance. This is partly because they have aged differently, but also because their present pairing does not reflect the original structure of the book. The program of decoration appears to have been that each Gospel was preceded by a page of symbols, a portrait of the evangelist, and an elaboration of the opening words of the Gospel. Thus, it is likely that a portrait of St Mark originally came between folios 129 and 130. In common with most major pages in the Book of Kells, the missing portrait was probably produced on a single leaf, the task of copying the text entrusted in the meantime to other hands. Single leaves tended to become detached more easily from the text block and lost over time.

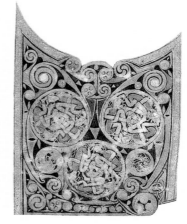

Detail from fol. 130r;
(overleaf) fols 179v–180r, *Book of Kells*

aedificabo & non erat conueniens testi
monium illorum exsurgens sum
mus sacerdus in medium & interro
gauit ihm dicens non respondis quic
quam ad ea quae tibi obiciuntur ab
his ille autem tacebat & nihil re
spondit rursum summus sacerds
interrogabat eum & dicit ei es
tu xps filius dei benedicti :.
Ihs autem dixit ei ego sum & ui
debitis filium hominis seden
tem a dexteris uirtutis & uenientem
in nubibus caeli :.
Summus autem sacerdus scindi
uestimenta sua & ait .
Quid adhuc desideramus testes
audistis blasfemiam eius quid

28

uobis uideatur quiomnes contempla
uerunt eum essereum mortis

Coeperunt quidam conspu
ere eum & uelare faciem
eius & colophis eum cedere & dice
re ei profetiza & ministri alapis
caedebant eum

Cum esset petrus inatrio de
orsum uenit una exancellis
summi sacerdotis & cum uidisset
petrum cale facientem se aspiciens
illum ait & tu cumihu nazareno
eras & ille negauit dicens neque
scio neque noui quiddicas

exit foras ante atrium
& gallus cantauit rursus
autem cumuidisset illum ancilla

Book of Kells folios 179v–180r

It is difficult, for reasons of interpretation, to venture a precise translation of any page from the Book of Kells. The nearest equivalent in English to its text occurs in the Douai version of the Bible:

Mark 14

58 [We heard him say: I will destroy this temple made with hands, and within three days] I will build [another not made with hands].

59 And their witness did not agree.

60 And the high-priest rising up in the midst, asked Jesus, saying: Answerest thou nothing to the things that are laid to thy charge by these men?

61 But he held his peace, and answered nothing. Again the high-priest asked him, and said to him: Art thou the Christ the Son of the blessed God?

62 And Jesus said to him: I am. And you shall see the Son of man sitting on the right hand of the power of God, and coming with the clouds of heaven.

63 Then the high-priest rending his garments, saith: What further need have we of witnesses?

64 You have heard the blasphemy. What think you? Who all condemned him to be guilty of death.

65 And some began to spit on him, and to cover his face, and to buffet him, and to say unto him: Prophesy; and the servants struck him with the palms of their hands.

66 Now when Peter was in the court below, there cometh one of the maid-servants of the high-priest.

67 And when she had seen Peter warming himself, looking on him she saith: Thou also wast with Jesus of Nazareth.

68 But he denied, saying: I neither know nor understand what thou sayest. And he went forth before the court; and the cock crew.

69 And again a maid-servant seeing him, [began to say to the standers-by: This is one of them.]

Folios 179v–180r contain St Mark's Gospel chapter 14, verses 58–69, which continue the account of Jesus before the high priest and council, while Peter denies Jesus for the first time.

folio 179v
aedificabo et non erat conueniens tes/
timonium illorum exsurgens sum/
mus sacerdus in medium et interro/
gavit iesum dicens non respondis quic/
quam ad ea quae tibi obiciuntur ab
his ille autem tacebat et nihil re/
spondit rursum summus sacerdus
interrogabat eum et dicit ei tu es
christus filius dei benedicti.
Iesus autem dixit ei ego sum et ui/
debitis filium hominis seden/
tem a dextris uirtutis et uenientem
in nubibus caeli.
Summus autem sacerdus scidit
uestimenta sua et ait
Quid adhuc desideramus testes
audistis blasfemiam eius quid

folio 180r
uobis uidetur qui omnes contempna/
uerunt eum esse reum mortis
Et coeperunt quidam conspu/
ere eum et uleare faciem
eius et colophis eum cedere et dice/
re ei prophetiza et ministri alapis
caedebant eum
Et cum esset petrus in atrio se/
orsum uenit una ex ancillis
summi sacerdotis et cum uidisset
petrum cale facientem se aspicens
illum ait et tu cum iesu nazareno
eras at ille negauit dicens neque
scio neque noui quid dicas
Et exiit foras ante atrium
et gallus cantauit rursus
autem cum uidisset illum ancilla

The sign '/' in the transcription signifies the frequently unusual division of words at the end of lines to achieve some justification of lines. Square brackets [] indicate text taken from preceding or following pages in order to retain the sense of passages. Abbreviations are expanded. Several scribal errors may be noted, such as 'seorsum' for 'deorsum' on folio 180r lines 8–9. In the Book of Kells, words are frequently run together, as at the end of the first line of folio 179v.

Several comments may be made about this opening. Firstly, reference should be made to the hand in which it is written. While all four major scribes who worked on the Book of Kells (referred to as A, B, C and D) can be found in St Mark's Gospel, folios 179v–180r are the work of scribe 'D', arguably the most accomplished of the four, who combined the decoration of the page with its transcription. There is space in this essay to draw attention to only a few examples of his expertise. On folio 179v line 10, prominence is given to the face of Jesus, in the bowl of the 'h' of the Greek abbreviation of his name, 'ihs', precisely at the point where he proclaims his divinity. The word 'ihs' is combined skilfully with 'xps', the Greek abbreviation of the word 'Christus'. An entire line is allotted to this statement, and there is virtually no decoration on the lines above, in order to emphasise its significance when it occurs. On folio 180r line 15, a hare, with strong hind legs and long ears, is contorted into the shape of the letters 'Et'. As a medieval symbol of timidity, the hare might be regarded as an appropriate occurrence at the point in the text where Peter denies Jesus.

Detail from fol. 180r, *Book of Kells*

There are several striking physical features to this opening. The stitching of long lateral slits in the parchment on both folios took place in the course of repair and rebinding in 1953. The corrugation running down the centre of folio 180r is the spine of the calf from which the page was made. A vertical spine such as this is an unusual feature, as the spine runs horizontally on most pages of the Book of Kells.

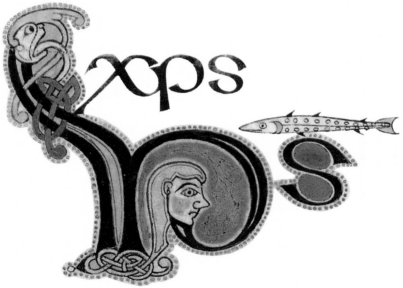

Detail from fol. 179v; (overleaf) fols 182v–183r, *Book of Kells*

uerunt illum purpura Et induerunt

eum uestimentis suis

educunt illum utcruci fig

rent eum Et angariaue

runt praetereuntem quendam

simonem cyrineum uenientem de

uilla patrem alexandri Et rufi

uttollerat crucem eius

perducunt illum ngolgo

tha locum quod est inter

praetatum caluariae locus

Dabant ei bibere murra

tum uinum Et non accipit

Crucifigentes eum diuise

runt uestimenta eius mit

tentes sortem super eis quis quid

tolleret

33

Book of Kells folios 182v-183r

Folio 182v contains St Mark's Gospel chapter 15, verses 20–24, in which Jesus is led to Golgotha and crucified.

Douai version
Mark 15

20 [And after they had mocked him,] they took off the purple from him, and put his own garments on him, and they led him out to crucify him.
21 And they forced one Simon a Cyrenian who passed by, coming out of the country, the father of Alexander and of Rufus, to take up his cross.
22 And they bring him into the place called Golgotha, which being interpreted is, The place of Calvary.
23 And they gave him to drink wine mingled with myrrh; but he took it not.
24 And crucifying him, they divided his garments, casting lots upon them, what every man should take.

folio 182v

[ex]uerunt illum purpura et induerunt
eum uestimentis suis
Et educunt illum ut crucifige/
rent eum et angarizaue/
runt praetereuntem quendam
simonem cyrineum uenientem de
uilla patrem alexandri et rufi
ut tolleret crucem eius.
Et perducunt illum in golgo/
tha locum quod est inter/
praetatum calvariae locus
Et dabant ei bibere murra/
tum uinum et non accipit
Et crucifigentes eum diuise/
runt uestimenta eius mit/
tentes sortem super eis quis quid
tolleret

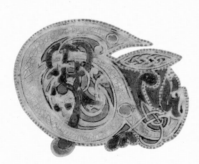

Detail from fol. 182v, *Book of Kells*

Translation:
However, it was the third hour
[And they crucified him]

The second line appears on the following page, folio 183v.

Appropriately, in a passage dealing with the Crucifixion, three of the four 'Et's at the beginning of lines in folio 182v contain crosses. On line 3, a beast with long ears gazes up, with an expression which might be construed as one of horror at the reference to Christ's being taken out for Crucifixion. A patch on this line repairing damage from copper green pigment on the previous page, folio 182r, partially obscures the 'e' at the end of the line.

Folio 183r contains St Mark's Gospel chapter 15, verse 25, and the following words:

ERAT
AUTEM
HORA TERCIA
Et crucifigentes
eum
diuise[runt]

The words on folio 183r — set out diagrammatically at right — are accompanied by an angel with outspread wings holding an open book, or perhaps a waxed writing tablet. The angel wears a purple pallium over a blue garment, has sandals and red painted toenails. It may be noted that splashes of red — barely visible to the naked eye — occur in the lozenge of chequered decoration to the angel's left. Panels of decoration at each of the four corners of folio 183r contain snakes, not drawn with any great refinement. Yellow, from the mineral orpiment, is prominent on folios 182v–183r. Even a glance will reveal that the pigment is heavily depleted and vulnerable, almost 'alligatoring' in appearance.

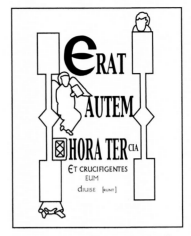

Diagram of fol. 183r, *Book of Kells*

There is a textual peculiarity to the opening 182v–183r. The words 'Et crucifigentes eum diuise' which appear in red, outlined in purple, on folio 183r, have on occasion confused scholars, as they represent a rearrangement of the text remarkable even by the lax standards of the Book of Kells, which contains many scribal errors. The explanation is simple, however, if we accept that scribe 'B', who had an especial fondness for working with coloured inks, lifted the phrase in its entirety from line 14 of the page opposite, the work of scribe 'D', at a time when he was engaged in completing and enhancing the manuscript. It may have been at this stage in the production of the manuscript that the blond head, probably that of Jesus, was added to the top right of folio 183r, and his feet and the lower section of his cloak were added to the lower left. It is presumably no accident that Jesus' garment, in accordance with the text, is purple, the Roman imperial colour and the colour of sacrifice, or that the words 'Et crucifigentes eum diuise' on folio 183r, referred to above, have a purple filler, echoing the very word 'purpura', used to describe the garment, which appears diagonally opposite at the centre of the top line of folio 182v.

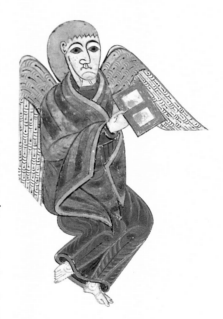

(above and below) Details from fol. 183r, *Book of Kells*

I am indebted to Felicity O'Mahony for helpful comments on a draft of this essay. (B.M.)

The Legacy of the Book of Kells: Medieval and Renaissance Illumination
Margaret Manion

The Book of Kells is not the first illuminated manuscript to have made the journey to the Antipodes. Medieval and Renaissance books, being eminently portable, may be found today in all corners of the globe; and more than two hundred such books, or fragments thereof, are now in art galleries and libraries in Australia and New Zealand. With the permission of the heads of these institutions, and the assistance of their curators, fifty-five of these works have been on the move again, this time taking up temporary residence in the National Gallery of Australia as part of an exhibition that celebrates the era of the handwritten, illuminated book, on the occasion of the presence in Australia of one of the most famous examples of this genre.

The manuscripts selected for exhibition span the twelfth to the sixteenth centuries, and document the development throughout Europe of a branch of painting that was intimately related to literacy and the communication of ideas through the skills of writing and reading. They represent a wide range of books — books for medieval scholars, books used in the public worship of the Church or the liturgy, personal prayer books, and splendid books in Latin or the vernacular by classical and humanist authors, produced for patrons who were both connoisseurs of art and great book lovers, such as the fifteenth-century dukes of Burgundy and the great Renaissance patron, Lorenzo de' Medici.

The examples, too, are of many different origins: Byzantine, English, French, Italian, Dutch and Flemish. Each book engages the viewer in its own way and raises a variety of questions to be probed further; but they have been grouped in the exhibition specifically to direct attention to two main aspects. The first group emphasises the relationship between text and decoration and the ways in which the design and decorative elements continued to underpin the art of illumination throughout its long history.

The second group of manuscripts highlights the essential connection between manuscript painting and the meaning of the text itself. These manuscripts have been selected with specific reference to the varied expression throughout the centuries of the intent and meaning of the Gospels, of which the Book of Kells is such a striking early example. The influences at issue here are both literary and visual: not only were the Gospels copied and illuminated in their entirety, but they gave rise to a vast number of different books. Readings from the Gospels, for example, form the core of the liturgical books used for the Mass and the Divine Office, since this solemn public prayer was structured within the rhythm of the Church year that commemorated the life, death and Resurrection of Christ, and his Ascension into Glory. The saving deeds of Christ were also presented as continuing in the life of the Church; Gospel texts, therefore, were also used to celebrate these feasts. In a visual sense, the Gospels are the basic source of the rich imagery of Christian art that unfolds throughout the course of western history.

By presenting a series of illustrated liturgical and devotional books from the twelfth to the sixteenth centuries, the exhibition provides insights into some of the ways in which the Gospels were expressed in the visual language and cultural idiom of many different times and places. These later illuminations, in their turn, highlight both the extraordinary creativity of the Book of Kells and the way in which the pages of this ancient work communicate, in word and image, the message of the Gospels in keeping with the intent of their attributed authors and with the spirit in which they continued to be proclaimed in the ensuing centuries.

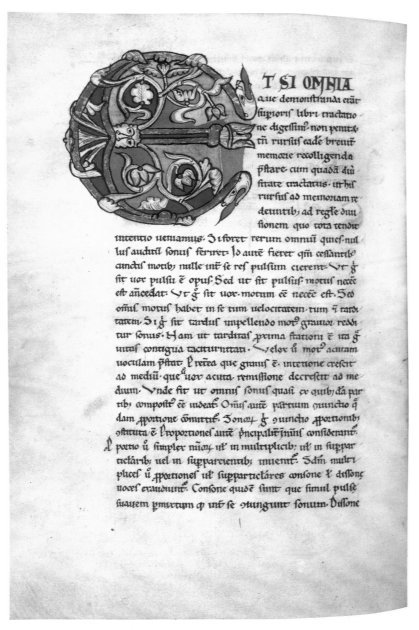

Decorated Initial 'E', Cat. No. 2

TEXT AND DECORATION
Medieval illumination

1. DECORATED INITIAL 'A'

Edmer, *Life of St Wilfrid*; (and Bede, Excerpt from *Historia Ecclesiastica*), Latin

England, mid-12th century

Parchment, 22.5 x 16.0 cm 37 leaves

Ballarat Fine Art Gallery, MS Crouch 10, fol. 1r

Often the beginning of a medieval text, not otherwise illuminated, was marked by a decorated letter. This Life of St Wilfrid, which was copied by an English scribe, opens with a large initial 'A', coloured in red, blue and green inks and decorated with a simple foliate design. Some of the chapter divisions in the manuscript are also marked by plain initials in red ink, three to six lines high, while many smaller initials throughout the text were once decorated with colour which has now flaked off.

Manion and Vines, 1984, No. 47; Muir and Turner, 1998;

B.J. Muir in *Gold and Vellum*, 1989, No. 34

2. DECORATED INITIAL 'E' (illus. previous page)

Boethius, *De Musica;* (and Guido of Arezzo, *Micrologus*), Latin

England (Christ Church, Canterbury), *c.*1125–50

Parchment, 21.1 x 14.4 cm 102 leaves

Alexander Turnbull Library, National Library of New Zealand/Te Puna Mātauranga o Aotearoa, MSR-05, fol. 50v

The splendid intial 'E' is one of five Romanesque initials that introduce the book-divisions in a medieval copy of the treatise on music by the philosopher Boethius (480–524). The initials are composed of vegetal, interlace and zoomorphic motifs, in which a winged dragon and dragon-heads feature prominently — characteristics that have been associated with Norman illumination. The *De Musica* was listed in the library of Christ Church Cathedral Priory, Canterbury, in the twelfth century; and a Norman, or Norman-influenced scribe, may have written and illuminated it there. The text of this finely crafted manuscript is accompanied by explanatory diagrams, several of which are ornamented with animal forms, and by a group of figural illustrations relating to the work's technical exposition.

Manion, Vines and de Hamel, 1989, No. 140; J. Stinson in *Gold and Vellum*, 1989, No. 28

3. HISTORIATED INITIAL 'P'

Glossed Epistles of St Paul, Latin

Tuscany, c.1190–1200

Parchment, 32.0 x 20.5 cm 151 leaves

State Library of Victoria, *f096/B47E, fol. 85v

Biblical texts were major subjects of study for medieval scholars. This initial comes from a late twelfth-century Tuscan copy of the Epistles of St Paul, complete with glosses or commentaries — this was a particularly popular text and many examples survive. Decorated initials 'P' customarily introduced each of the Epistles in these manuscripts, with one initial being reserved for the author portrait. The curling white vine-stems, patterned interlace and occasional animal motifs of the decorated initials are characteristic of Italian Romanesque illumination, and it was this kind of decoration that was mistaken later by Italian humanist scholars for the work of classical antiquity, and copied by them (See Nos 13–16). Plain initials in alternating red and blue ink mark the paragraphs of the marginal glosses.

Manion and Vines, 1984, No. 2; Hubber, 1993, 6

4. DECORATED INITIAL 'R'

Gradual, Latin

Lombardy, second half of 13th century

Parchment, 30.5 x 23.0 cm 200 leaves

State Library of New South Wales, Dixson Q 3/1, fol. 88v

The initial 'R' of the word 'Resurrexi' (I have risen) marks the introit chant for the Mass of Easter Sunday in this thirteenth-century choir book or gradual. It is one of six large initials that introduce the Mass chants for the major feasts of the Church. The naturalistic interlace of curling acanthus leaf design reflects both the use of classical motifs in medieval Italian art and the three-dimensional character of Gothic ornament. Several examples of choir books which contain the chants used in the liturgy of the Mass (graduals) and the Divine Office (antiphonals) appear in this exhibition. This particular gradual, written in the second half of the thirteenth century, was updated with various additions about a century later. The rubrics indicate that it was made for a Cistercian community, and the fourteenth-century section records its use in the abbey of Cornu, identified as San Stefano, Cornu, in the diocese of Lodi. The decoration is relatively simple, in keeping with Cistercian principles.

Manion and Vines, 1984, No. 5

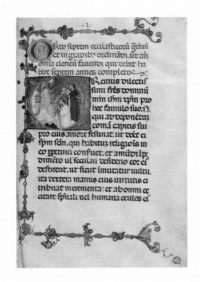

5. HISTORIATED INITIAL 'O': AND BORDER

Pontifical; (with later excerpts from *Summa Theologica*
of St Thomas Aquinas and *Rules for finding the new moon*), Latin
Central or Northern Italy, second half of 14th century
Parchment, 27.6 x 20.0 cm 164 leaves
Ballarat Fine Art Gallery, MS Crouch 5, fol. 3r

An historiated initial, six lines high, and a three-sided decorative border
mark the beginning of the rite of ordination in this pontifical, a book
designed for the rituals and blessings carried out by a bishop. The page
is also headed by an introductory rubric with an initial in blue ink, pen-
flourished in red. The historiated initial depicts the first grade of ordination:
the cutting of the tonsure. It shows the bishop attacking the locks of the
kneeling cleric with a large scissors. As he does so, he reads prayers from
a pontifical held open before him by two acolytes. The border is of Italian
Gothic design; its elongated stem is punctuated by clusters of finely
tapering acanthus leaves, knots and gold balls. A bird and the tiny head
of a bearded man appear in the lower left-hand corner.

Manion and Vines, 1984, No. 11; M.M. Manion in *Gold and Vellum*, 1989, No. 3

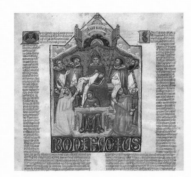

6. DEDICATION MINIATURE

Boniface VIII *Book VI of Decretals*; Giovanni d'Andrea, *Glosses on
Book VI,* Latin
Bologna, late 14th century
Parchment, 45.0 x 27.5 cm 127 leaves
University of Sydney Library, Rare Books and Special Collections,
MS Nicholson 32, fol. 1r

This popular legal text was written in a particular format. It presented
the decretals or canon law ordinances of the thirteenth-century pope
Boniface VIII, in the centre of the pages, with the commentary or gloss
of Giovanni d'Andrea in two columns, one on either side. This detail of
the opening page of the manuscript shows the beginning of the gloss,
with a dedication miniature in the space normally reserved for the text
of the decretals. These do not begin until the next page. In the miniature,
Boniface is shown seated in an authoritative frontal pose, handing down
the decretals in the presence of the Roman curia. The group includes
cardinals, clerics, petitioners and a notary. The pope's name is inscribed
in gold letters beneath the scene. Smaller initials with figures and
decorative motifs introduce the columns of the gloss, as well as marking
divisions throughout the text. Bologna, a university city, was an important
centre of manuscript production, and legal texts were one of its specialties.
This manuscript comes from the workshop of Niccolò da Bologna, one
of the most productive Bolognese illuminators of the fourteenth century.

Manion and Vines, 1984, No. 17; M.M. Manion in *Gold and Vellum*, 1989, No. 35

7. DECORATED INITIAL 'B'; AND BORDER

Psalter, Latin

England (probably London), beginning of 15th century

Parchment, 19.4 x 12.9 cm 201 leaves

Bible Society in New Zealand. On loan to the Alexander Turnbull Library, National Library of New Zealand/Te Puna Mātauranga o Aotearoa, MSR–01, fol. 7r

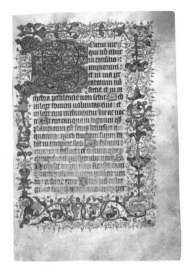

The psalms of the Old Testament were early adopted by the Church as the basis for Christian prayer, and the book of psalms or the psalter was often illuminated. In this English manuscript, decorated initials and borders mark the beginning of the psalter and its division into sections for recitation throughout the week, based on liturgical custom. Psalm 1 begins with the words 'Beatus vir' (Blessed is the man — who does not walk in the ways of the wicked), hence the term 'Beatus page'. It is marked here by a large decorated initial, patterned with acanthus leaves, and by a four-sided or full border of interlinked and curving stems, with trumpet-shaped flowers and acanthus, and two prancing dragons at the lower corners. The lacy tendrils that radiate from the border's central spine are characteristic of fifteenth-century English decoration

Manion, Vines and de Hamel, 1989, No. 135

8. DECORATED INITIAL 'D'; AND BORDER

Book of Hours, Use of Sarum, Latin and English

England, first half of 15th century

Parchment, 14.2 x 9.5 cm 160 leaves

National Library of Australia, Clifford Collection, MS 1097/2, fol. 13r

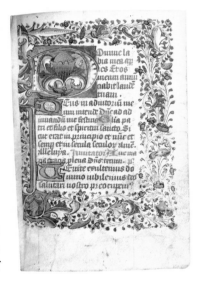

Initial and border decoration mark the opening page of the Hours of the Virgin in this English book of hours. The lush, curling acanthus leaves, the pomegranates and the feathered sprays are familiar motifs of fifteenth-century English illumination. Like the psalter above (No. 7), the illumination is not illustrative.

Manion and Vines, 1984, No. 46; M.M. Manion in *Gold and Vellum*, 1989, No. 11

9. CALENDAR PAGE

Book of Hours, Use of York, Latin

Bruges, late 15th century

Parchment, 34.5 x 23.5 cm 72 leaves

State Library of Victoria, *f096/R66 Hb, fol. 2r

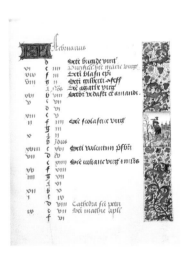

The calendar was an important medieval text which regularly appeared in liturgical and personal prayer books. It was based on an ancient Roman model, although the feasts celebrated were Christian ones. The calendar had its own special format, with a series of vertical and horizontal divisions for the entry of computational data, as well as the names

of seasonal feasts and saints' days. The layout, and use of gold and coloured inks to differentiate the various elements, gave the calendar a decorative emphasis. Its usual placement at the beginning of a book also attracted decoration. This was particularly the case with late medieval calendars in psalters and books of hours for personal use. In this calendar from a late fifteenth-century book of hours, which was made probably in Bruges for an English patron, important feasts are written in red (from which comes the phrase 'red letter days'). The miniature in the border depicts the activity for the month of February: the cutting of trees for firewood.

Manion and Vines, 1984, No. 56; M.M. Manion in *Gold and Vellum*, 1989, No. 21; Hubber, 1993, 6; Vines, 1993, 80–91

10. VEIN MAN AND ZODIAC MAN

Portable Calendar, Latin
North-eastern England, 15th century
Parchment, 26.4 x 15.7 cm 5 leaves
Ballarat Fine Art Gallery, MS Crouch 4, fol. 5r

The distinctive format of this calendar or almanac reflects its specific purpose. It belongs to a small group of portable calendars made for the use of medical practitioners. The calendar itself contains additional tables for telling the time, calculating eclipses, movements of the sun and moon and the conjunction of the planets. These pages were to be used in association with the accompanying illustrations of the Vein Man and the Zodiac Man, which reflect the medieval belief that human physical well-being was governed by astronomical forces.

Manion and Vines, 1984, No. 44; V.F. Vines in *Gold and Vellum*, 1989, No. 43

11. DEDICATION PAGE (illus. opposite)

Livy, *History of Rome*, French
Paris, *c.*1400
Parchment, 44.0 x 32.5 cm 510 leaves
National Gallery of Victoria, MS Felton 411–4, fol. 8r

The French translation of Livy's History of Rome is divided into three decades of ten books each. The group of four miniatures that illustrate this opening page of the first decade show, from upper left to right: (1) the presentation by the translator, Pierre Bersuire, of his work to King Jean le Bon, (2) the discovery of Romulus and Remus, (3) Romulus promulgating the laws of Rome, and (4) the battle of the Horatii and Curiatii. The miniaturist has been called the Cité des Dames Master after his illumination of several copies of the *Cité des Dames*, written by Christine de Pisan in 1405. He was responsible for one of the leading Parisian workshops of the day, and everything about this manuscript —

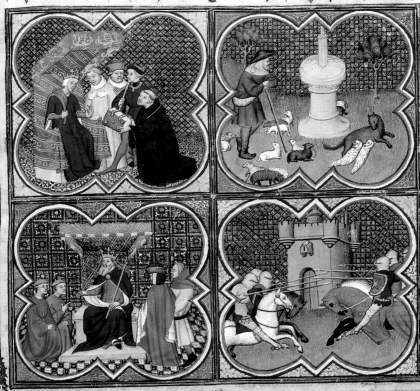

SE ie me pruis a esarpue
les choses faites par les
rommains des le com
mencement que rom
me su sondee ie ne say
pas se ce sera chose con
uenable. Et se ie le say
si ne lose ie dure pur
ce que ie voy que cest vne chose qui par les
anciens a la este escripte et publiee. Mais
pour ce que les nouueaux sapteurs cuidont
et opinent dure et reater tous iours auat
ne chose plus vraye et plus certaine en
la riere de lanuen langaige sourmonter
et langaige et matiere desdauier par plus
ancieue langaige pour ce il me plaist me
dier et conseillier ou auoir conseillie en
ma partie atenir en memoire les sais de
cestuy puiple qui est princes des terres et
si a eu si grant tourbe de sapteurs qui les
dittes choses ont escript auant moy. ma

renomince est petite et oblante ie me con
freteray en la grandeur et en la noblesce de
ceste qui nunont amon nom. Cest adure
que il ne me desplaist pas se ie suis pou pri
sies au regart de si sollempnelles persoues.
Et toutesuoyes sera il chose de tresgrant
labour pour ce que il couuendra reputer et
desarpre les choses qui sont faites des vii.
cens ans. [L]esquelles sont trouuees
de pris commincemens et tant creues.
Car apresent la grandeur diceles leur
est laidunense. Et si ne doubte point que
reater les premieres nessancs de cestuy
puiple et les choses prouchaunes a son co
mincement seront maims deleitables a ceste
qui les liront que ne cruisent les choses du
temps present esquelles vertus et les for
ces de cest puiple sont si grans sur elles on
suument et legattent son miesmes. Et ce
sera donques ie loyer demon trauail que
ie demanderay. Cest adure que en repetant

its high quality parchment, regular Gothic script, meticulously executed ivy-leaf initials and borders, ornamented 'baguette' spines, and the extensive series of miniatures — indicates its *de luxe* nature. In addition to the elaborate pages which introduce each of the three decades, the beginning of the prologue and of individual books is marked by a series of miniatures, the width of a column of text. The illustrations express the ideals of wise statesmanship and superiority in tactical warfare to which Bersuire refers in his preface. Rome is held up as a model for France to emulate in this regard. Dignified discussion and debate are a recurrent theme throughout the pictorial cycle. So, too, are battle scenes. These are rendered in romantic chivalric terms, with no attempt to classicise, either in costume or in settings. The illustration of the discovery of Romulus and Remus has overtones of the pastoral idyll, a theme which also influenced religious compositions, such as the Annunciation of the birth of Christ to the Shepherds (See No. 43). The first owner of the Melbourne Livy is unknown, but it later belonged to Antoine, Grand Bâtard de Bourgogne (1421–1504), one of the great bibliophiles of the fifteenth century.

Manion and Vines, 1984, No. 72; M.M. Manion in *Gold and Vellum*, 1989, No. 36; Hubber, 1993, 10

12. RITUAL FOR CONFIRMATION

Pontifical, Latin

France, *c*.1500

Parchment, 48.0 x 32.5 cm 149 leaves

State Library of Victoria, *f096. 1/R66 P, fol. 4r

The lavish use of costly pigments and gold in this manuscript shows that no expense has been spared to provide a sumptuous work for the patron, who is identified by the arms on this page and elsewhere as Philippe de Levis, archbishop of Mirepoix. The border decoration, which employs alternating coloured and white grounds, and geometric divisions in the manner of late French illumination, is competently executed. So, too, are the figures and settings of the small miniatures, which show the bishop administering the sacrament of confirmation, even though their surfaces are somewhat harsh and unmodulated. The design of the page, however, is disconcerting. The text space neither floats illusionistically in front of the border, nor is framed by it, while the script is confusingly cramped and overcrowded with decorative cues. One wonders if the format has been negatively influenced by a printed model. The strangest feature of all is the replacement of the initials of the opening words of the prayers by two miniatures — disproportionately small. Thus, despite the opulent appearance of this manuscript, its pages reveal

that the long-cherished principles governing the relationship between text and decoration are in the process of disintegration.

Manion and Vines, 1984, No. 85; V.F. Vines in *Gold and Vellum*, 1989, No. 4; Hubber, 1993, 7–8

Renaissance humanist illumination

13. DECORATED INITIAL 'O'

Aristotle, *Ethics* (translated Leonardo Bruni), Latin
Florence, *c.*1430–40s
Parchment, 26.5 x 17.5 cm 120 leaves
University of Sydney Library, Rare Books and Special Collections,
MS Nicholson 24, fol. 5r

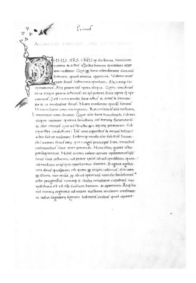

While Italian Renaissance scholars continued the tradition of copying texts by hand, they introduced new criteria for both script and illumination. The formal humanistic script of this translation of Aristotle's *Ethics*, distinguished by its clarity and balance, mirrors the renewed scholarly interest in the philosophy of Greece and Rome. The gold initials set on blue grounds with green and faded red infills are ornamented with the white vine-stem motif, developed by Renaissance illuminators in emulation of the work of the ancients. In reality, however, this motif is of twelfth-century Romanesque origin (See No. 3). The finely rendered butterflies foreshadow later Florentine interests in more naturalistic motifs.

Manion and Vines, 1984, No. 21

14. TITLE PAGE

Flavius Josephus, *The Jewish War* (translated Rufinus of Aquileia), Latin
Florence, *c.*1445–59
Parchment, 34.0 x 24.5 cm 186 leaves
Auckland Central City Library, Special Collections, Med. MS G.147, fol. 1r

The regular unadorned script of this manuscript, with its few abbreviations, is eminently readable. Only the title page is singled out for border decoration, while a series of initials, decorated in white vine-stem, mark the beginning of the preface and the books into which the history is divided. The border, in particular, is characteristic of the work of Filippo di Matteo Torelli, who played a key role in the development of white vine-stem decoration. The birds that perch in the vine on either side of the initial, and the easy stance of the vase-bearing putto in the lower left corner, punctuate and accentuate the rhythmic symmetry of the border in a manner typical of Torelli.

Manion, Vines and de Hamel, 1989, No. 26; C. O'Brien in *Gold and Vellum*, 1989, No. 38

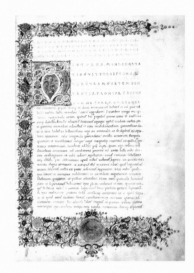

15. TITLE PAGE

Leonardo Bruni, *History of the Florentine People*, Latin
Florence, 1465
Parchment, 34.5 x 23.5 cm 204 leaves
University of Sydney Library, Rare Books and Special Collections,
MS Nicholson 15, fol. 1r

It has been suggested that Amerigus Corsinus, the scribe who signed and dated this manuscript, may have been only in his early teens when he copied it. Both he and his older brother, Philippus, worked in humanist circles in the second half of the fifteenth century. While the initial-portrait of Leonardo Bruni is framed with white vine-stem, the border is the floral 'tendril' type, developed in Florence as the century progressed. The illumination is of high quality and has been attributed to the circle of Francesco d'Antonio del Chierico, who was active in the development of the new decorative style.

Manion and Vines, 1984, No. 23; C. O'Brien in *Gold and Vellum*, 1989, No. 39

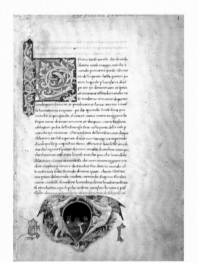

16. TITLE PAGE

Leonardo Bruni, *The First Punic War* (Anonymous translation), Italian
Veneto, *c*.1450–75
Paper, 27.2 x 18.0 cm 64 leaves
University of Sydney Library, Rare Books and Special Collections,
MS Nicholson, 9, fol. 1r

This copy of an Italian translation of the history of the first Punic War, written originally in Latin by the Florentine humanist, Leonardo Bruni, highlights Italy's common cultural heritage and, at the same time, its pronounced regional distinctions. Bruni's achievements were respected and his works read in the north. Likewise, the white vine-stem decorative motif that had originated in Florence moved northward. As this page demonstrates, however, the forms of the vine in the north are more three-dimensional and the foliage more naturalistic and more lush. The elongated bodies of the putti on either side of the shield at the base of the page are characteristic of northern Renaissance centres such as Padua. This work also provides an example of the use of paper for Renaissance books, a practice that became increasingly widespread, even for the ornamented manuscript, as better quality paper became available.

Manion and Vines, 1984, No. 26

17. DEDICATION PAGES

Breviary, Latin

Perugia, *c.*1475

Parchment, 33.5 x 22.6 cm 390 leaves

Auckland Central City Library, Special Collections, Med. MS G.134, fols 306v–307r

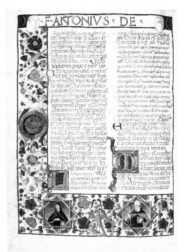

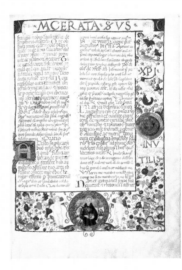

In this breviary — a book which contains the Divine Office for daily recitation by clerics and members of religious orders — Renaissance humanist decorative motifs are blended with more traditional medieval elements. The script is in a rounded Gothic liturgical hand, but the inscription, written across the top of this double-page opening and down the outer border of the right-hand page, is in gold capitals which imitate the lettering on classical monuments. It reads 'F. Antonius de Macerata, s[er]vus Christi inutilis' (Fra Antonius de Macerata, worthless servant of Christ). The use of epigraphic inscriptions in manuscript illumination originated in Padua in the 1460s, in the circle of Mantegna and a group of antiquaries who included Felice Feliciano, who wrote a treatise on the subject. The practice soon spread to other parts of Italy. The nude putti and the wreaths in the delicately rendered floral border are also classical in spirit, though they enclose Christian images and symbols. In the side border panels, the wreaths encircle the crown of thorns and the cross; and the image of the saint in the lower margin of the right-hand page is also framed by a wreath. Antonius de Macerata, a distinguished member of the Augustinian order, was active in Perugia, where this manuscript was probably produced, from the 1460s to the 1480s. Its Augustinian connection is clear from the importance given in both text and illustration to saints venerated by that order. This particularly elaborate double page marks the feast of St Augustine himself. He is shown, together with his mother, St Monica, in the lower margin of the left-hand page, while the Augustinian saint, Nicholas of Tolentino, appears opposite.

Manion, Vines and de Hamel, 1989, No. 14; C. O'Brien in *Gold and Vellum*, 1989, No. 8

18. TITLE PAGE

Scriptores Historiae Augustae; Eutropius *Breviarium ab Urbe Condita;*
Paul the Deacon, *Historia Romana*, Latin

Florence, 1478/79

Parchment, 37.8 x 25.0 cm 216 leaves

State Library of Victoria, *f096.1/Au 4, fol. 1r

The opening folio of this splendid manuscript displays the arms and devices of the great Florentine patron of the arts, Lorenzo de' Medici.

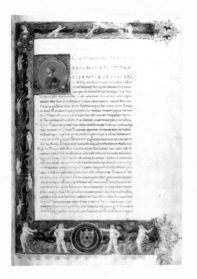

In its three-sided border, winged putti encircle a green trunk that represents Lorenzo's emblem of the pruned laurel branch with shoots. Scrolls bearing the words 'Le Tens Revient' (The Seasons Return) wrap around it. They signify the return of a golden age under the Medici, whose coat of arms appears in the border at the bottom of the page, both in the central wreath and on the shields held by putti on either side. Flowers strew the ground of the border panel, and on the upper left an angel stands behind a gleaming jewel cluster.

Cecilia O'Brien has shown that, in keeping with Lorenzo's own interests, the illumination of this manuscript expresses a blend of courtly chivalric values with those of Renaissance humanism, and that all of these devices can be interpreted in this context. The scribe signed the manuscript with his motto, 'Omnium rerum vicissitudo est' (Ups and downs are in the nature of things) — a phrase taken from *The Eunuch* by the Roman playwright, Terence. The scribe has been identified as Neri Rinuccini; and the illuminator is Mariano del Buono di Jacopo (1433–1504).

Eighty-one historiated initials illustrate the lives of the Roman emperors with half-length portraits and busts. The representation of Hadrian on the title page begins the series; it is based on a well-known image from a Roman coin. Three other compositions are presented in the form of coins, but, apart from that of Hadrian, the portraits themselves are not modelled on classical protoypes. Rather, as O'Brien demonstrates, the artist has depicted the imperial rulers in terms of artistic conventions currently in use for both secular and religious figures. The initials are set on burnished gold grounds, elegantly patterned, and have partial tendril borders of Florentine floral design.

Professor Albinia de la Mare, the distinguished professor of paleography, has recently examined this book: she comments, 'This is truly a manuscript of the highest quality, even in the context of those made for Lorenzo de' Medici. It is particularly precious among surviving manuscripts from the Medici collection because it is still in its original binding while the Medici manuscripts in the present Biblioteca Medicea Laurenziana in Florence were bound in the sixteenth century.'

C. O'Brien in Manion and Vines, 1984, No. 31; C. O'Brien in *Gold and Vellum*, 1989, No. 40; Hubber, 1993, 7–8; O'Brien, 1993, 72–77

ILLUMINATING THE WORD
Gospel texts and images

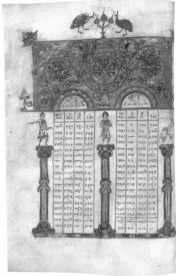

19. DECORATED CANON TABLES

Byzantine Gospels, Greek
Constantinople, *c*.1150
Parchment, 24.2 x 17.4 cm 254 leaves
National Gallery of Victoria, MS Felton 710–5, fols 3v–4r

Canon Tables, which were formulated by Eusebius of Caesarea in the early fourth century, regularly introduce the Gospels in eastern and western Gospel books. They present both the common and the distinctive subject matter of the four texts in a series of comparative tables, each of the Gospels having been divided into numbered sections as a basis for this analysis. In addition to serving the utilitarian function of helping to locate specific Gospel passages, the Canon Tables stress the individual and comprehensive character of each Gospel and the inter-relatedness of all four. They were interpreted as the Church's official guarantee that these accounts were the authentic expression of Christian faith and teaching, handed down from the apostles.

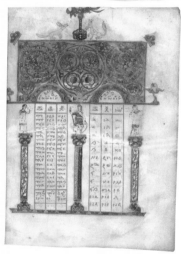

The tradition of decorating the Canon Tables goes back to the earliest known illuminated Gospel books of the sixth century. In this fine Byzantine Gospel book, produced in Constantinople probably towards the middle of the twelfth century, decorative panels of intricate foliate design, set on a gold ground, surmount the tables which are framed by simulated marble columns. The figures on the columns are an adaptation of western motifs. From left to right on folio 3v, they show the labours of the month — December, January, and February; and on folio 4r, the monastic virtues: Prudence, Courage, and Thoughtfulness. Decorative panels also mark the opening words of each of the Gospels, which are written in gold. The evangelist portraits which originally faced these pages have been removed, but their impression is visible in some places.

M. Riddle in Manion and Vines, 1984, No. 1; M.M. Manion in *Gold and Vellum*, 1989, No. 1; Hubber, 1993, 10; Spier and Morrison, 1997, No. 4

20. PASSION NARRATIVE: MATTHEW 26. 59–75

Gospels (fragment), Latin
France, 9th/10th century
Parchment, 26.5 x 19.5 cm 2 leaves; 30.0 x 21.5 cm 1 leaf
Dunedin Public Libraries, Alfred and Isabel Reed Collections,
Reed Fragment 1, fol. 1v

One bifolio and one single leaf survive of this ancient Gospel book. The left-hand page of the bifolio (fol. 1v) is an extract of St Matthew's

account of the Passion. The marking of the text with the tiny letters 'c' (cantor), 's' (synagogue) and '+' (Christ) indicates that the Gospel book, from which this fragment comes was used in the liturgy of Palm Sunday for the dramatic recital of the Passion, in which the account was divided up into the parts of Christ, the narrator, and other characters. The practice is still observed today. The text is written in a fine Carolingian minuscule (small case letters), with red capitals set out into the margins. Christopher de Hamel has also drawn attention to the fact that these leaves were also used as wrappers for legal papers in the seventeenth century.

Manion, Vines and de Hamel, 1989, No. 65

21. GOSPEL OF ST LUKE 1. 5–14

Gospels, Middle English
England, 15th century
Parchment, 16.8 x 11.5 cm 133 leaves
Dunedin Public Libraries, Alfred and Isabel Reed Collections,
Reed MS 6, fol. 60r

A burnished gold initial on a parti-coloured blue and red ground introduces each of the four Gospels in this English translation of the Gospels, which is the later of the two versions made in the name of John Wyclif (d.1384). It is a less literal translation than the first version, which kept close to the Latin Vulgate. Rather, it follows the revised English translation associated with John Purvey (d.1428). Wyclif's teachings were declared heretical, and neither of these versions received official endorsement by the Church.

Manion, Vines and de Hamel, 1989, No. 62

22. THE TRINITY: BOOK OF GENESIS

Bible, Latin
Italy, mid-13th century
Parchment, 28.0 x 20.8 cm 438 leaves
Bible Society in New Zealand. On loan to the Alexander Turnbull Library, National Library of New Zealand /Te Puna Mātauranga o Aotearoa, MSR–16, fol. 3v

St Jerome's Latin translation of the Old Testament in what came to be known as the Vulgate edition of the Bible was accepted as canonical by the Church, although there were various revised editions throughout the Middle Ages, including that associated with the University of Paris in the thirteenth century. The illustration of Genesis, the first book of the Bible, with an historiated initial showing the Trinity, demonstrates how the Old Testament was interpreted from a Christian perspective. The Church proclaimed that the mystery of the Trinity — that is, the existence of three persons in God — was revealed by the life

and words of Christ. The Fathers of the Church and later theologians interpreted certain passages of the Old Testament as foreshadowing this mystery. Thus the statement in the plural by the Creator in Genesis (1. 26), 'Let us make man in our own image', was seen to indicate the plurality of persons in God. The image here is based on one of the traditional iconographical forms for representing the Trinity in the west. The two identical figures of Christ express the doctrine that, as the Son of God and the divine Logos or Word, he is the mirror of God the Father. His humanity thus allows the Godhead to be expressed in visual terms. The dove was the traditional symbol of the Holy Spirit, the third person of the Trinity. Shown linking Father and Son, as here, it expresses the relationship of love that characterises the inner life of the Trinity.

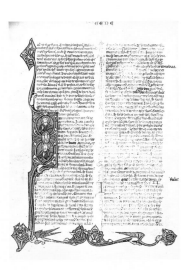

The script of this manuscript is Italian, and an inscription indicates its presence in the abbey of St John the Baptist in Monza, diocese of Milan, in the fourteenth century. It was probably written in northern Italy and illuminated there by an artist working in the French Gothic style.

Manion, Vines and de Hamel, 1989, No. 134; M.M. Manion in *Gold and Vellum*, 1989, No. 2

23. CRUCIFIXION (illus. overleaf)
Missal, Vol. 1, Latin
Besançon, *c.*1465
Parchment, 30.5 x 22.5 cm 244 leaves
Auckland Central City Library, Special Collections,
Med. MS G.138, fol. 158r

In the illuminated missal — the book used for the celebration of the Mass or Eucharist — a representation of the Crucifixion usually marked the beginning of the Canon, the solemn prayer of thanksgiving which commemorated Christ's Passion and death on behalf of the human race. This full-page miniature in a richly illuminated two-volume missal, produced for use in the diocese of Besançon, incorporates some of the narrative and devotional elements associated with the Crucifixion in the fifteenth century. The scene is set in an expansive landscape in which Jerusalem appears as a medieval city with turreted towers and a Gothic church. In the left foreground, the upright figure of Mary, robed in deep blue, manifests dignity and fortitude while, behind her, the centurion pierces Christ's side. Although blood pours from his wounds, Christ, too, communicates an air of calm authority. The skull and scattered bones at the foot of the cross allude to the legend that the Crucifixion took place on the site of Adam's grave, and that Christ's death restored the promise of eternal life lost by Adam. The cross in the decorative border beneath

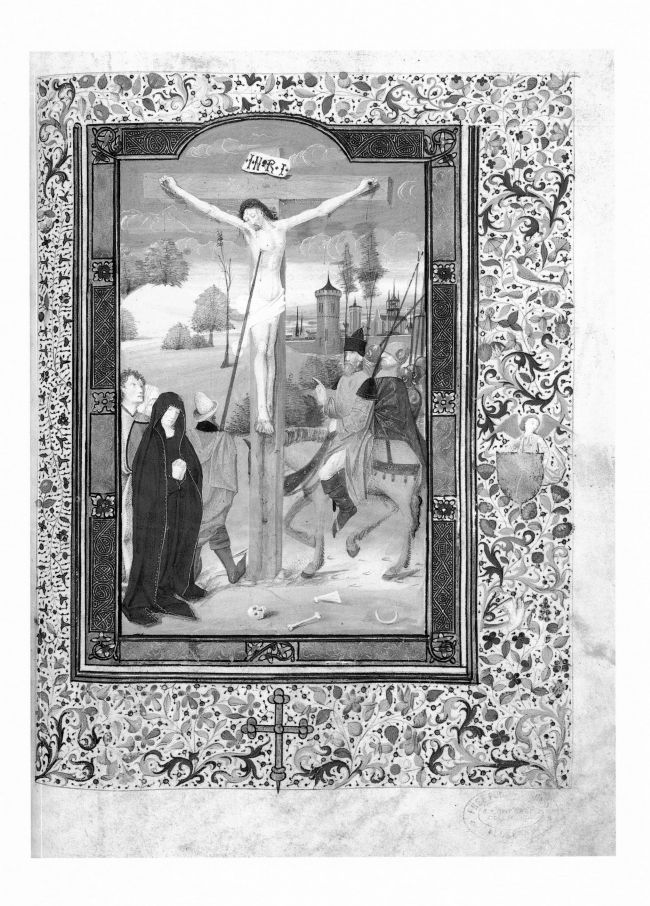

the miniature refers to the Mass ceremonial, the celebrant being required to kiss it during the recitation of the Canon.

The Crucifixion was often accompanied at this place in the missal by a scene of Christ in Majesty. This is the case here: on the following page, Christ is shown enthroned, surrounded by the four beasts of the Apocalypse bearing Gospel books. The same theme appears in Early Christian Church decoration and on the pages of early Gospel books.

This missal was made for Charles de Neufchâtel, who was elected archbishop of Besançon in 1464 and exiled in 1480 — his arms, which appeared in both volumes, have been painted over in most places.

Manion, Vines and de Hamel, 1989, No.18; V.F. Vines in *Gold and Vellum*, 1989; Vines, 1991, 127–147; Vines, 1998, 195–223

24. PIETÀ

Apollonio de' Bonfratelli, *Missal* (fragment), Latin

Rome, mid-16th century

Parchment, 25.3 x 17.5 cm single leaf

National Gallery of Australia, 76.1320AB

This single leaf with a painting of the Pietà probably comes from a missal made for Pope Pius V, for use in the Sistine Chapel. It is the work of Apollonio de' Bonfratelli who was, from 1554–75, papal miniaturist at the Vatican, where manuscripts continued to be made for liturgical purposes long after they had been replaced elsewhere by printed books. Illuminated manuscripts were amongst the booty carried off by the French after the invasion of Rome in 1798, and cuttings or detached leaves from these books later found their way into private collections and auction houses.

While the Crucifixion regularly illustrated the Canon of the Mass in the missal, other scenes were occasionally added. In late Renaissance illumination, depictions of the Descent from the Cross, the Lamentation, and the Pietà were not unusual. This image of the Pietà, in which Mary mourns her dead son whose body is stretched out on her lap, is indebted to the masters of the High Renaissance and to contemporary mannerist painters. Michelangelo, in particular, had made the Pietà theme popular in Rome. The verses on alternating blue and red panels, inset into the frame of the painting, which are based on the Lamentations of Jeremiah, and Isaiah, are used in the Office of Holy Week. 'O vos omnes, qui transitis per viam / attendite et videte. Si est dolor similis / sicut dolor meus' (Oh all you who pass by the way, look and see; is there any sorrow like to my sorrow) Jeremiah 1. 12. 'Dolores Nostros ipse tulit et peccata Nostra ipse portavit' (Ours were the sufferings he bore; he has carried the weight of our sins) Isaiah 53. 4–5. The verse from Jeremiah had long been applied to the Virgin. The theme of Mary the Mother of

Sorrows, who shares intimately in the sufferings of her son and invites the Christian to identify with her compassionate grief, is of ancient origin and goes back as far as the Byzantine liturgy of the fifth century. It later emerged as a key element of devotion to Christ's Passion in western medieval art and literature, especially in Italy.

C. O'Brien in Manion and Vines, 1984, No. 34 ; J.J. Alexander in *The Painted Page*, 1994, No. 136

25. NATIVITY

Antiphonal, Latin
Central or Northern Italy, late 13th/14th century
Parchment, 57.0 x 39.5 cm 180 leaves
State Library of South Australia, fol. 5v

The feast of Christmas was usually singled out for major decoration in illuminated choir books, as in this Italian antiphonal. In the context of the responsorial chant that it accompanies, 'Hodie nobis celorum rex de virgine nasci dignatus est' (Today the king of heaven deigned to be born for us of a virgin), this painting celebrates the birth of Christ as the revelation of God's splendour in human form. In keeping with a tradition that goes back to Early Christian times, the reclining figure of Mary Theotokos, the Mother of God, dominates the scene. Above her, the swaddled infant Christ lies in a box-like manger, while angels gesture towards him in homage. The representation of the ox and ass leaning over the crib, has traditionally been interpreted as a reference to Isaiah 1. 3, 'The ox knows his owner, and the ass his master's crib: but Israel does not know me'. It is thus a call to faith in the Incarnation. So, too, is the scene in the lower foreground which shows two midwives bathing the new-born baby. Their action emphasises the humanity of the infant Christ, while the challenge that this represents for the believer is reflected in the figure of the seated, pondering Joseph.

Manion and Vines, 1984, No. 5; M.M. Manion in *Gold and Vellum*, 1989, No. 29; Tonkin, 1998

26. NATIVITY

Antiphonal (fragment), Latin
Northern Italy, 13th/14th century
Parchment, 55.5 x 38.0 cm single leaf
Dunedin Public Libraries, Alfred and Isabel Reed Collections, Reed Fragment 18

The responsory for the feast of Christmas is introduced in this Italian antiphonal in similar vein to No. 25. Although this Nativity scene is somewhat more curtailed, its figures being limited to Mary,

Joseph and the swaddled infant, the ox and the ass are, nevertheless, in attendance. Mary and Joseph are more dramatically rendered, as with raised hands they appear to acclaim the good tidings.

Manion, Vines and de Hamel, 1989, No. 81; M.M. Manion in *Gold and Vellum*, 1989, No. 47

27. NATIVITY

Gradual, Latin

North-east Italy, 1427

Parchment, 46.0 x 31.0 cm 177 leaves

Bishop's House, Ponsonby, Auckland, fol. 24r

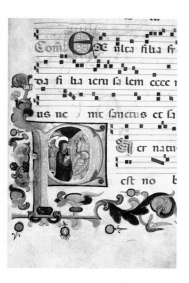

The Introit chant for the Mass of Christmas, 'Puer natus est nobis' (Unto us a child is born), is introduced in this fifteenth-century Italian gradual by a Nativity scene which, like those in the earlier antiphonals (Nos 25 and 26), expresses the theme concisely. The ox and the ass feature prominently, and a pondering Joseph can be glimpsed in the background. Instead, however, of reclining after the birth of her son, Mary now kneels to worship him, and a western stable replaces the cave of Byzantine tradition. These changes reflect certain developments in medieval piety associated in particular with the Franciscan order. The image of Mary kneeling to adore her child, for example, is based on a description in the *Meditationes Christi* written by the Franciscan, Johannes de Caulibus, where the viewer is invited to participate imaginatively in the Gospel events and, with Mary, kneel and worship the infant Christ.

Manion, Vines and de Hamel, 1989, No. 47

28. NATIVITY (illus. overleaf)

Antiphonal (fragment), Latin

Flanders, early 14th century

Parchment, 33.0 x 21.5 cm single leaf

Private collection

There is an air of Gothic elegance about this page from a fourteenth-century Flemish antiphonal, which is in contrast to its more sturdy Italian counterparts. It is smaller in size, and the more closely spaced script and musical notation are complemented by a graceful cusped bar border in which gold and light blue predominate. The Nativity scene in the lower margin fits appropriately into this context. Mary is shown here in a conventional western-type bed, complete with bolsters and blue coverlet, as she tenderly grasps the infant Christ. The gold and blue tessellated backdrop and the architectural frame, with its series of arches, suggest a domestic interior, rather than the Christmas stable. The ox and the ass are pastured outside, and Joseph is busy cooking

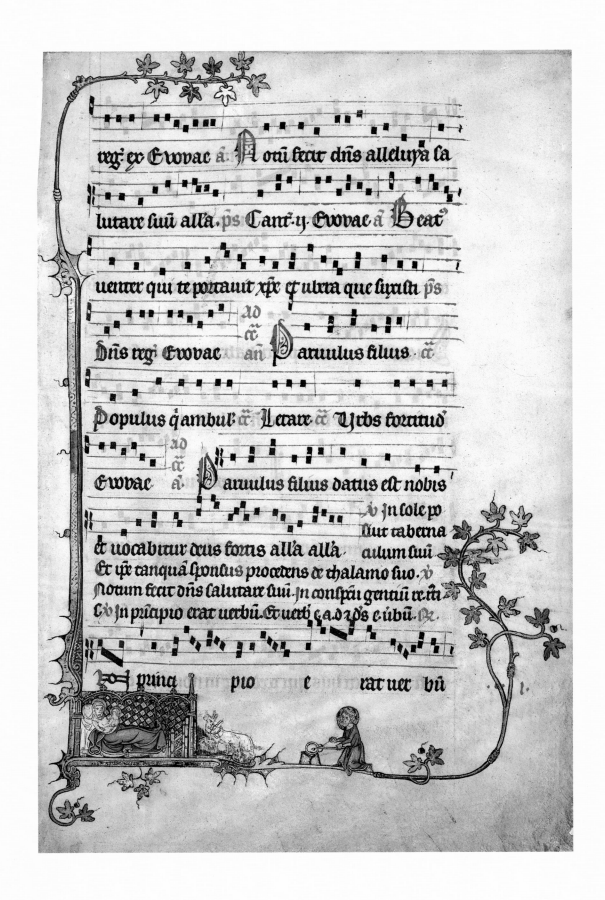

a meal over a brazier. Such details derive from contemporary drama as well as reflecting the imaginative emphasis in devotional writings of the time. The scene illustrates the responsory 'In principio erat verbum' (In the beginning was the word), John 1. 1, and John Stinson has pointed out that the musical setting for this is unusual and that it may reflect the usage of a particular diocese or religious order. The page was owned in the nineteenth century by the English writer, John Ruskin.

29. MASSACRE OF THE INNOCENTS

Antiphonal (fragment), Latin
Northern Italy?, 13th/14th century
Parchment, 48.0 x 34.0 cm 7 leaves
State Library of Victoria, *ef.096/R 661, fol. 1v

The feast of the Holy Innocents is held three days after Christmas. It honours as martyrs the children slaughtered by King Herod, in his attempt to kill the new-born Christ whom he saw as a potential threat to his reign in Judaea. In this fragmentary section of an Italian antiphonal, the Massacre is graphically depicted. Above, soldiers receive their orders from Herod, while below the slaughter takes place. In the melee of soldiers and slain bodies, certain aspects are singled out for emphasis. The disproportionately large sword wielded by the soldier on the right, for example, is contrasted with the gesture of lamentation of the bereft mother next to him. She and the group of sorrowing women on the left allude to the words of Jeremiah, cited by Matthew in his account of this event (2. 18), 'A voice was heard in Ramah, sobbing and loudly lamenting: it was Rachel weeping for her children, refusing to be comforted because they were no more'. The placing of the feast of the Holy Innocents in Christmas week, together with the feast days of the martyrs, Stephen and Thomas à Beckett, juxtaposes joy at Christ's birth with the foreshadowing of his sufferings and death. It also relates the life and sufferings of the saints to that of Christ.

Manion and Vines, 1984, No. 7; Hubber, 1993, 6

30. CHRIST AND MARTYR SAINTS

Neri da Rimini, *Antiphonal*, Latin
Rimini, 1328
Parchment, 52.5 x 36.5 cm 155 leaves
State Library of New South Wales, Rare Books and Special Collections, Richardson 273, fol. 34v

This manuscript is one of a set of choir books illuminated by the talented artist Neri da Rimini, for a religious house in Rimini. It contains the chants for various categories of saints — martyrs, confessors,

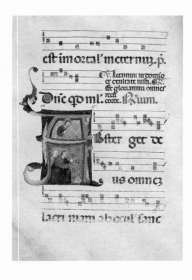

virgins etc. — which are used when a feast does not have a special office of its own. The bond between Christ and those who suffer on his behalf is the subject of the historiated initial 'A' which marks the responsory for matins of the office of several martyrs. Christ appears against a gold ground in the upper part of the initial while, from below, two kneeling nimbed figures look towards him, and the halo of a third is visible behind them. The words of the text make the meaning of the picture clear. Based on the Apocalypse (7. 17), they speak of the reward that awaits those who have been persecuted for the Lord's sake, 'Absterget Deus omnem lacrimam ab oculis sanctorum: iam non erit amplius neque luctus, neque clamor, sed necque clamor, sed nec ullius dolor: quoniam priora transierunt' (God shall wipe away every tear from the eyes of his saints: there will no longer be any mourning or crying or anguish, for the former things have passed away).

Manion and Vines, 1984, No. 8; R. Gibbs in *Neri da Rimini*, 1995, No. 31; Dauner, 1995, 445–446; Dauner, 1996, 8–9

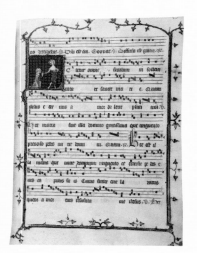

31. THE RISEN CHRIST APPEARS TO MARY MAGDALEN

Antiphonal, Latin
Paris, *c*.1335–45
Parchment, 28.5 x 20.0 cm 428 leaves
State Library of Victoria, *0961/R66 A, fol. 287r

This scene illustrates matins for the feast of St Mary Magdalen in a fourteenth-century French antiphonal made for Dominican nuns at the monastery of St Louis de Poissy. It is based on the account in John's Gospel (20. 11–18) of the appearance of Christ to Mary after his Resurrection. Mary Magdalen was a popular saint in the Middle Ages and although scholars debate whether she is identical with Mary, the sister of Martha and Lazarus, and Mary the converted sinner, the figure venerated in both the liturgy and personal prayer encompasses all three. Sometimes, she was portrayed in flamboyant terms of gesture and costume, but in the Poissy antiphonal she kneels before Christ in modest contemporary dress, a model for the nuns for whom the book was made. The scene, nevertheless, highlights her close, personal relationship with Christ, which is also the theme of the office, 'Let every age rejoice in the solemnity of the blessed Mary, whom with eternal love, Jesus loved exceedingly' (responsory for matins). The illumination is executed in the elegant Parisian style associated with the later phase of the workshop of Jean Pucelle.

Manion and Vines, 1984, No. 71; J. Stinson in *Gold and Vellum*, 1989, No. 30; Hubber, 1993, 7–8; Naughton, 1993, 38–49; Stinson, 1993, 50–59; Naughton, 1995, vol. 1, 73–102, vol. 2, No. 32; Naughton, 1998, 67–110

32. THE ASCENSION

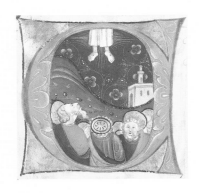

Psalter? (fragment bound with three other fragments), Latin
Lombardy, mid-15th century
Parchment, 10.5 x 10.5 cm single leaf
State Library of Victoria, *f096/II. 1, fol. 1r

This fragment may come from a liturgical psalter used in the celebration
of the Divine Office, and the style and colour of the illumination —
especially the combination of the blond tones of faces and hair with
intense pink, blue, green and red — indicates that it was probably
made in Lombardy. Book illumination flourished there in the fifteenth
century, with many fine works being produced for both clerical
patrons and those of the North Italian courts. This particular way of
illustrating the Ascension which shows the disciples gazing heavenwards,
where only the feet and lower portion of Christ's body are visible as he
disappears into the clouds, originated in English art at the beginning
of the twelfth century.

Meyer Schapiro has pointed out that it reveals an imaginative leap,
at a very early period, towards the more naturalistic depiction of religious
events, which is usually associated with Gothic art. By contrast to the
traditional ways of representing the return of Christ to the Father after
the fulfilment of his redemptive mission, in terms of a classical apotheosis
or the triumphant appearance of Christ aloft in clouds of glory, the
event is shown here as taking place from the perspective of the disciples;
and the viewer is asked to identify with their experience. By the fifteenth
century, this had become an accepted way of depicting the Ascension.

Schapiro, 1979, 266–287; Manion and Vines, 1984, No. 19; Hubber, 1993, 6

33. ASCENSION AND PENTECOST

Psalter-Hours, Latin and French
Liège, 1270s
Parchment, 17.0 x 12.0 cm 270 leaves
State Library of Victoria, *096/R66, fol. 19v

The psalter was used for personal devotion as well as in the Divine
Office. In the thirteenth century, selections from the offices and other
prayers from the breviary — the book that contained the Divine Office
— were attached to the psalter in a prayer book called a psalter-hours.
This page from a psalter-hours made for a person in the diocese of Liège
shows the Ascension of Christ and the Descent of the Holy Spirit at
Pentecost. These images conclude a series of miniatures of the life of
Christ, which preface the psalter. Indeed, they announce the beginning
of the psalter itself, being contained within the 'Beatus' initial of the
first psalm. The practice of introducing the psalter with a series

of illustrations goes back to twelfth-century England. The frequent dedication of these series to the life of Christ was one of the many ways in which the psalms were presented in a Christian context. Male and female saints appear in quatrefoils let into the frame that contains the Beatus initial. This is a further indication of how the prayers and illustrations of this prayer book interpret both the Old Testament and the history of the Church in terms of the life of Christ and the all-encompassing theme of salvation history. The Melbourne psalter-hours belongs to a distinctive group of manuscripts many of which, as Judith Oliver has shown, were probably made for lay religious women called Beguines. They were active in charitable works and their devotional life, which involved the recitation of the psalter and various offices, was strongly influenced by Franciscan and Dominican spirituality.

Manion and Vines, 1984, No. 69; Oliver, 1988, especially, vol. 2, No. 25; Hubber, 1993, 7; Oliver, 1993, 24–29

34. BIRTH OF THE VIRGIN

Breviary, Use of Sarum, Latin
London, 1330–50
Parchment, 10.0 x 6.8 cm 256 leaves
The University of Melbourne Library, Archives and Special Collections, fol. 173r

One of the popular feasts in the medieval Church calendar was the Birth of the Virgin. This event does not appear in the Gospels, but apocryphal accounts of Mary's life before the Annunciation had always been popular and greatly influenced Christian art. While the Church stressed that the Gospels alone were canonical, it honoured certain other traditions relating to persons appearing in the Gospels. Thus there was a special Mass and breviary office devoted to the Birth of the Virgin. The scene which illustrates the feast in this English breviary is modelled on the Nativity of Christ. St Anne, the mother of Mary, is shown in bed with a small swaddled baby in a cradle nearby, and an attendant midwife at her side. This tiny book contains the psalter and the breviary offices for the saints' feasts. It originally formed the second part of a more extensive volume that included a liturgical calendar and the seasonal or temporal feasts of the Church year. The first section is now in the Bodleian Library, Oxford (MS Laud Misc. 3a). The book is one of only twenty known English breviaries from the first half of the fourteenth century, and was probably produced in London or Oxford, perhaps for the use of a parish priest.

Manion and Vines, 1984, No. 43; V.F. Vines in *Gold and Vellum*, 1989, No. 6; Michael and Morgan, 1993, 32–37

35. PRESENTATION OF THE VIRGIN

Aspremont Psalter-Hours (Hours section), Latin

The Lorraine, *c.*1290–1302

Parchment, 21.5 x 15.0 cm 139 leaves

National Gallery of Victoria, MS Felton 1254–3, fol. 1r

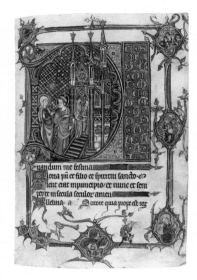

The richly illuminated Aspremont psalter-hours is now divided into two parts, with the psalter section being in the Bodleian Library, Oxford (Ms Douce 118), and the offices or hours for the feasts of Christmas, the Purification, Annunciation, Assumption, and Birth of the Virgin in a volume in the National Gallery of Victoria. The hours section is introduced with an elaborate historiated initial at the first vespers of Christmas, showing the Presentation of the Virgin. Joachim and Anne, the parents of Mary gesture to each other as their small daughter mounts the temple steps where a priest waits to receive her. The images in the quatrefoil medallions set into the cusped, ivy bar-border indicate the future that awaits the young Mary. In the upper right of the border is a Crucifixion scene, with Mary and St John on either side of the cross; and in the middle of the right-hand border Mary appears as queen of heaven holding the infant Christ. In the remaining two medallions, the owners of the prayer book, the knight Joffroy d'Aspremont and his wife Isabelle de Kievraing, are shown with hands raised in prayer, while, in the bottom margin, a rabbit plays a trumpet and an archer fits an arrow to his bow.

The imagery of this page announces the themes elaborated in the course of the book. These include the life of Mary up to the Annunciation, based on popular apocryphal sources, her role in the events of Christ's infancy, her death, Assumption and Coronation. Throughout the book the patrons appear in various attitudes of prayer, and Joffroy is also shown in knightly combat. The margins are filled with playful drolleries, animals and hybrids, and allusions to popular folklore and secular activities are plentiful. The illumination of this manuscript thus foreshadows the devotional emphases of the book of hours, which was to become the popular lay prayer book of the noble and wealthy literate classes, particularly in England and Northern Europe. Contemplation of the life of Christ, especially the events of his infancy and of his Passion and death, lies at the heart of these devotions. This contemplation is undertaken in the company of Mary, and it explores imaginatively the human dimensions of the Christian message, including the various ways it is lived out in the lives of Mary and the saints.

Manion and Vines, 1984, No. 70; M.M. Manion in *Gold and Vellum*, 1989, No. 9; Hubber, 1993, 10; Manion, Knowles and Payne, 1994, 25–34

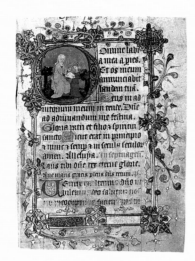

36. ST ANNE TEACHING THE VIRGIN TO READ

Book of Hours (fragment bound with later Book of Hours), Latin

London, *c.*1405

Parchment, 18.0 x 12.5 cm 8 leaves inserted in book of 126 leaves

Dunedin Public Libraries, Alfred and Isabel Reed Collections,
Reed MS 5, fol. 9r

Devotion to St Anne, the mother of Mary, was particularly popular in medieval England where a feast in her honour was introduced into the Church calendar in 1378. This depiction of St Anne teaching the Virgin Mary to read comes from the pages of an English book of hours which are now attached to a book of hours made in Flanders in the late fifteenth century for an English patron, Margery Fitzherbert. The painting, though worn, is high-quality English work, and it was probably executed in London at the beginning of the fifteenth century. The themes of the book and of reading are often associated with representations of Mary and the saints in books of hours. Such images act as an exemplar for the devotee, who was aided in prayer by both the written word and its illumination.

Manion, Vines and de Hamel, 1989, No. 61; M.M. Manion in *Gold and Vellum*, 1989, No. 16

37. VIRGIN AND CHILD

Book of Hours, Latin

Florence, late 15th century

Parchment, 11.5 x 8.0 cm 248 leaves

Ballarat Fine Art Gallery, MS Crouch 2, fol. 13r

The portrayal of the Virgin Mary with the Christ Child in her arms is one of the oldest images of Christian art. It appears constantly in books of hours in a wide range of contexts and with varying devotional emphases. In this Florentine book of hours, it introduces the Hours or Little Office of the Virgin. Like the putti in the Renaissance border, Christ is portrayed nude and is of sturdy proportions. His cross-nimbus is a reminder both of the sufferings he will endure and of his divine status.

Manion and Vines, 1984, No. 20

38. VIRGIN AND CHILD

Book of Hours, Latin

Northern Italy, second half of 15th century

Parchment, 15.4 x 11.0 cm 141 leaves

National Library of Australia, Clifford Collection, MS 1097/6, fol. 1r

The page introducing the Hours of the Virgin in this Renaissance book of hours is similar in layout to No. 37. The colours and the design of the

border, however, indicate different regional emphases and the image of the Virgin and Child is also distinctive. The way in which the child lies across Mary's lap, and her hands joined in prayer over his body, relate it to depictions of Christ's infancy that foreshadow his Passion and death, and to the theme of the Pietà in which Mary laments her dead son (See No. 24).

Manion and Vines, 1984, No. 27

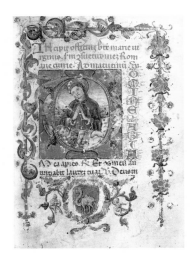

39. ANNUNCIATION; AND THE VIRGIN AND CHILD

Monte di Giovanni di Miniato, *Book of Hours,* Latin
Florence, 1496
Parchment, 14.7 x 10.0 cm 241 leaves
National Gallery of Victoria, MS Felton 869–5, fols 13v–14r

The Hours of the Virgin was a key devotion in the book of hours and since the Annunciation was often chosen to introduce its opening hour of matins, this theme received special attention. Here, according to a format popular in late fifteenth-century Florence, the Hours of the Virgin is introduced by a double-page composition which shows the Annunciation on the left and an historiated initial of the Virgin and Child set within a panel of crimson-stained parchment on the right.

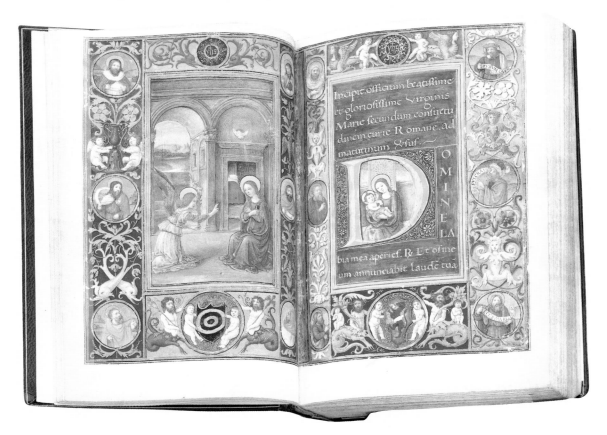

The introductory rubric and opening words of the office are written in gold on the crimson surface; and splendid border panels, with both classical and religious motifs, frame the two pages, giving the impression of a single integrated composition. Within this context, the Annunciation is presented as the single Gospel event for contemplation during the recitation of the Hours of the Virgin. The Virgin and Child opposite, and the individual saints in the border and in the historiated initials marking the later hours, serve to extend the contemplative focus so as to embrace the fulfilment of the angel's message and its continuing significance in the life of the Church.

The rendering of the Annunciation scene incorporates both contemporary Flemish and Italian influences. The stately architectural background and detailing are clearly Italian Renaissance, but the view of the Virgin's bedroom on the right derives from the panel paintings of fifteenth-century Flemish artists, such as Rogier van der Weyden, while the delicate landscape vista, although by now part of the idiom of Florentine painting, also owes something to the Flemish love of the combination of precision with naturalistic atmospheric effects.

This exceptionally fine Florentine book of hours may have been made for the wedding in 1496 of Lucrezia di Lorenzo Strozzi, niece of Filippo Strozzi, to Roberto de Donato Acciaiuoli, since the Strozzi and Acciaiuoli arms originally appeared on folios 13v and 14r respectively. (The Strozzi arms were later painted over with those of the Albizzi.) The manuscript is dated 1495 in two places (folios 130r and 221r); but taking into account that the Florentine calendar began on 25 March, the evidence indicates that it was copied in the first quarter of 1496 by our reckoning. It is written in formal humanistic script by the scribe Sigismondo de' Sigismondi of Carpi, whose hand Albinia de la Mare has identified in six other books of hours, four of which are signed by him. The illumination is the work of Monte di Giovanni di Miniato (1448–1529) who, together with his brother Gherardo (1446–1497), was responsible for a flourishing workshop in Florence in the late fifteenth and early sixteenth centuries.
C. O'Brien in Manion and Vines, 1984, No. 33; Garzelli and de la Mare, 1985, vol.1, 536, 598; C. O'Brien in *Gold and Vellum*, 1989, No. 23; Hubber, 1993, 10

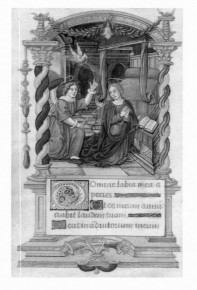

40. ANNUNCIATION
Book of Hours, Latin
Paris?, *c*.1510–20
Parchment, 14.5 x 9.0 cm 125 leaves
State Library of Victoria, *096/R66 Ho, fol. 23v
In many books of hours in Northern Europe, the Annunciation introduces at matins for the Hours of the Virgin a series of scenes that

continue through the office, marking the beginning of each hour. These comprise a sequence from the infancy of Christ, in which Mary features prominently, and one or more concluding scenes that refer to her death, Assumption or Coronation in heaven. In this sixteenth-century French book of hours, the Annunciation introduces such a sequence. Its setting compares with that of the Strozzi Hours (No. 39), with the combination of arcaded background, red-coverleted bed and exterior vista indicating that, by this time, certain compositional formats were well-established and widespread. The inclusion of the bed reflects references in devotional literature to the Holy Spirit entering Mary's bridal chamber, and their royal wedding or espousal. The script and the heavy ornamental framing structure of the miniature are clearly influenced by the Renaissance idiom, although the illumination lacks the elegance of the Florentine painting.

Manion and Vines, 1984, No. 87; Hubber, 1993, 6

41.VISITATION

Book of Hours, Latin
Eastern France? mid-15th century
Parchment, 18.4 x 13.3 cm 181 leaves
Bible Society in New Zealand. On loan to the Alexander Turnbull Library, National Library of New Zealand/Te Puna Mātauranga o Aotearoa. MSR–02, fol. 41v

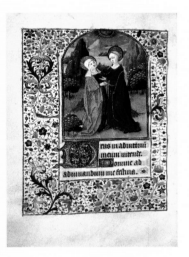

The Gospel records that on learning from the angel Gabriel that her cousin, Elizabeth, had also conceived a son — the future John the Baptist — Mary went with haste into the hill country to visit her (Luke 1. 39–56). A picture of the Visitation often introduces lauds in the Hours of the Virgin, as in this fifteenth-century French book of hours. The representation in art of the meeting of the two cousins goes back to Early Christian times, but the theme attracted renewed interest in the Gothic period, and the establishment in 1389 of a feast in honour of the Visitation reflects its increasing importance in late medieval spirituality. The ways in which the medieval artist expressed this theme still speak eloquently today. In this particular miniature, attention is concentrated on the two pregnant women, both conscious of the new life forming within them and of the destiny foreshadowed by the angelic messengers. Elizabeth, the older of the two, bows in respect for the future mother of Israel's Messiah, while the more youthful Mary forestalls her with an affectionate gesture, one arm raised before her, and the other reaching around her cousin's shoulder. The two meet in an uncluttered landscape in which tiny trees and conventional framing mountains are sprinkled with gold, and a radiating sun lights up the mountain slopes and buildings on the distant horizon. The provenance of this manuscript,

which has been illuminated by two different artists, is uncertain. There are some indications that it may come from a centre in eastern France, such as Dijon or Besançon, although Parisian influences are also evident.

Manion, Vines and de Hamel, 1989, No. 136; M.M. Manion in *Gold and Vellum*, 1989, No. 17

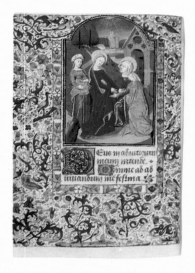

42. VISITATION

Book of Hours, Latin
Paris, *c.*1460–65
Parchment, 17.0 x 11.9 cm 254 leaves
University of Sydney Library, MS Additional 58, fol. 56v

This miniature illustrates lauds of the Hours of the Virgin, in a book of hours from the prolific Parisian workshop of the Master of Jean Rolin, who was active in Paris *c.*1445–65. Some scholars claim that he may originally have come from Burgundy, and he certainly carried out several important commissions for Cardinal Jean Rolin of Autun, after whom he has been named. Whether the links are by way of Burgundy or Paris, the miniature in this book presents the encounter between Mary and Elizabeth in basically the same compositional and iconographical terms as its counterpart in No. 41, apart from a few minor variations. In this book, for example, Mary has acquired a female attendant, and the meeting of the cousins, instead of being in the open countryside, takes place closer to the journey's end, as indicated by the dwelling behind Elizabeth and the turreted town nearby. The position of the figures is also reversed; but dress, colours, gestures and expression in the two miniatures follow the same basic pattern. This attests that illuminators and their patrons knew this kind of subject matter well. Occasionally they delighted in creative innovation, but more often they discerned the function of the painting to be in the nature of a prompt that brought to mind a particular Gospel story or related event, as one recited the psalms and antiphons of the Hours of the Virgin.

Manion and Vines, 1984, No. 77; M.M. Manion in *Gold and Vellum*, 1989, No. 18; Monks, 1995

43. ANNUNCIATION TO THE SHEPHERDS

Maître François, *Book of Hours,* Latin and French
Paris, *c.*1475
Parchment, 17.8 x 12.5 cm 116 leaves
National Gallery of Victoria, MS Felton 1072-3, fol. 37v

In western medieval art, by contrast to the Byzantine tradition, the various events surrounding the birth of Christ were represented in a series of scenes, independent of the Nativity itself. The Annunciation to the

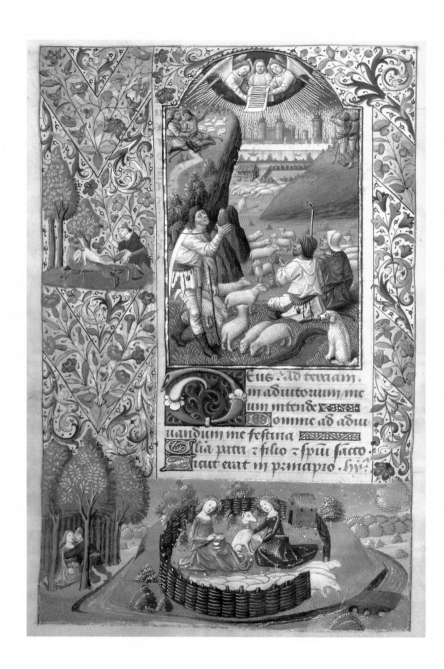

Shepherds regularly illustrated the hour of terce in the Hours of the Virgin after theNativity at prime; it is one of the most striking pages in this book — called the Wharncliffe Hours after a nineteenth-century owner. The book is a superb example of the work of Maître François, who succeeded the Master of Jean Rolin (See No. 42) as the head of a flourishing workshop in Paris in the later fifteenth century and who had noble patrons in Anjou and Maine.

The main miniature on this page depicts the event in terms of a joyous pastorale, with no attempt to indicate that it took place at night as the Gospel relates. Sheep crop the gold-tipped grass and the fold in the distance is empty, while boats glide along the river and medieval buildings that line its shores are clearly visible. Only the angels in the sky, singing from their shared music scroll, and the rapt attention of the shepherds who gaze heavenwards, indicate the spiritual significance of the scene. This interpretation reflects the influence of contemporary mystery plays, such as that of Arnoul Gréban, in which the shepherds make music and dance to rondels in the same joyous spirit, 'On parle de grand seigneurie/D'avoir donjons, palais puissans/est il liesse plus serie/que de regarder ces beaux champs?' (One tells of great lords who have castles and mighty palaces, but is there anything more delightful than to gaze on these beautiful meadows?).

With the exception of the seated shepherd on the right, the main figures in the miniature are dressed predominantly in shades of off-white, or grisaille, with rich contrasting blues and greens, or darker browns being used for accessories and the landscape setting. This colour scheme is reversed in the border whose bright colours are offset with white. White alternates as the ground to the border's gold geometric divisions, and picks out the details of hands and heads, of pet hound and sheep, helping to unify the overall decorative effect of the page. The playful spirit of the border scenes also complements the pastoral theme of the main miniature. In the lower margin, two young women, crowned with circlets of green leaves, relax in the security of a fenced enclosure which they share with a flock of sheep. They are all the more protected by the fact that they are situated on a small island. This is in lively contrast to the state of the young woman in a dense and tall wood, at lower left, who is the subject of the aggressive attentions of an admirer. Above the couple, a wolf making off with a sheep is hotly pursued by a stick-wielding shepherd — surely a humorous comment on the predatory nature of the scene in the wood.

Manion and Vines, 1984, No. 78; M.M. Manion in *Gold and Vellum*, 1989, No. 20; Hubber, 1993, 10

44. ADORATION OF THE MAGI

Book of Hours, Latin and French

North-eastern France, second half of 15th century

Parchment, 17.6 x 12.5 cm 150 leaves

National Library of Australia, Clifford Collection MS 1097/5, fol. 51r

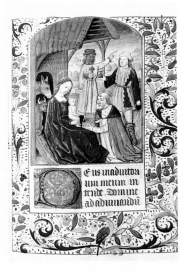

The visit of the Magi or wise men from the east to see the new-born Christ is related in Matthew 2. 1–12. Originally the Magi were associated with the wisdom of astronomy, being men who read the heavens and who were prompted by the appearance of a new star in the heavens to make the journey to Bethlehem. Subsequent interpretation, both literary and pictorial, transformed them into oriental kings, with an emphasis on the fact that they came to pay homage to the new ruler of the earth. The Church celebrates the visit of the Magi on the feast of the Epiphany, a term signifying the manifestation of the divine, with the Magi standing for the non-Jewish world or the Gentiles.

In the late Middle Ages, the Adoration of the Magi was a familiar theme in art, often providing the opportunity for the opulent display of the trappings of contemporary kingship. The scene regularly appears at the hour of sext as part of the infancy cycle which illustrates the Hours of the Virgin. This example from a mid-fifteenth-century French book of hours, possibly from the area of Chalons-sur-Marne, depicts the event with a simple, uncluttered dignity.

Manion and Vines, 1984, No. 76

45. DORMITION OF THE VIRGIN

Book of Hours, Latin

Central Italy, *c.*1375

Parchment, 10.2 x 7.9 cm 208 leaves

State Library of South Australia, fol. 96v

It was a long-held belief that Mary's body did not undergo the corruption of the grave. Mystery, however, surrounded the nature of her passing from this world. In the Byzantine tradition, her death was referred to as 'a falling asleep', and the feast of the Dormition of the Virgin had an important place in the Church calendar. Icons of the Dormition influenced Italian art, as this rendering of the theme in a fourteenth-century Italian book of hours demonstrates. The historiated initial which introduces vespers in the Hours of the Virgin shows the body of Mary lying on the top of a sarcophagus. Christ stands beside her, holding in his arms a small figure — this represents the soul of Mary which Christ himself has come to take to Paradise. Around him cluster the apostles, who have gathered at her death. According to certain traditions, Mary ascended bodily to heaven three days after her death.

There was thus scope for artists to depict both her Dormition and Assumption, as is the case in this book of hours where the Assumption follows at the hour of compline.

This unusual and beautiful little book was probably made in Central Italy. Its nineteen historiated initials present striking close-up depictions of sacred events, which intimately engage the viewer. Here, for example, the finely delineated features of Mary, as she lies in death, project beyond the initial into the viewer's space, and the loving presence of Christ is emphasised by his size and centrality, in contrast to the attendant apostles whose heads form a supportive arc around the couple.

Manion and Vines 1984, No. 14; M.M. Manion in *Gold and Vellum* 1989, No. 10; Stocks 1998(1), 111–152; Stocks 1998(2), especially iv–v

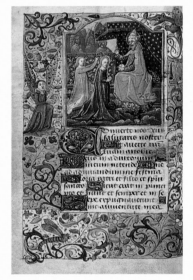

46. CORONATION OF THE VIRGIN

Book of Hours, Latin
Northern France, perhaps Rouen, 15th/16th century
Parchment, 16.8 x 11.2 cm 103 leaves
Dunedin Public Libraries, Alfred and Isabel Reed Collections,
Reed MS 8, fol. 36v

The theme of the crowning of Mary as Queen of Heaven, which emerged in the twelfth century, became immensely popular in later medieval art, appearing in painted altar panels, cathedral sculpture and stained glass, as well as in manuscript illumination. As the illustration for the concluding hour of compline in the Hours of the Virgin, the Coronation often provided a triumphant finale to the series of scenes commemorating Mary's participation in the early life of Christ. In this French book of hours, Mary kneels to be crowned before the canopied throne of God, depicted as a fatherly bearded figure wearing a papal tiara. Winged seraphim and swirling clouds beneath the figures indicate that the setting is the court of heaven. Mary is crowned here by an angel. Alternatively, God appears in the form of Christ-Logos and may perform the coronation. Mary, too, as the personification of the Church, sometimes appears in the guise of his royal consort, rather than his mother.

Manion, Vines and de Hamel, 1989, No. 64; M.M. Manion in *Gold and Vellum*, 1989, No. 25

47. PENTECOST

Book of Hours, Latin

Besançon, 1555

Parchment, 19.5 x 13.5 cm 254 leaves

Alexander Turnbull Library, National Library of New Zealand/Te Puna Mātauranga o Aotearoa, MSR–07, fol. 91v

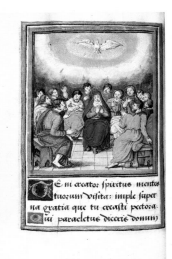

In many representations of the Descent of the Holy Spirit, Mary figures prominently, as in this illustration of the Hours of the Holy Spirit in a book of hours from Besançon. This is because as 'Mater Ecclesiae' (Mother of the Church) she stands for the believing Christian community. Mary is spoken of in these terms by the early Fathers of the Church and depictions of both the Ascension and Pentecost in Early Christian art already make her ecclesial role clear. In this sixteenth-century miniature, Mary is the focal point. The rich blue of her cloak, her position in the centre of the group and the fact that she is larger in scale than those around her, underline her symbolic importance. As tongues of fire come to rest on the heads of the assembled apostles, and the dove of the Holy Spirit hovers over the room where the group is gathered in Jerusalem, the Church which is to continue Christ's saving mission on earth is born. Mary, persevering in prayer with the apostles, signifies that Church and its indissoluble links with the God incarnate.

Manion, Vines and de Hamel, 1989, No. 153

48. THE MAN OF SORROWS

Book of Hours, Use of Utrecht, Latin

Cologne, 1450–75

Parchment, 9.5 x 6.7 cm 144 leaves

Trinity Methodist Theological College Collection.

On loan to Kinder Library, St John's College, Auckland. fol. 61v

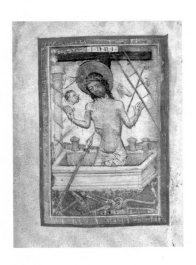

Devotion to the Passion of Christ figured large in medieval spirituality. Short offices of the Cross or Passion were regularly included in a book of hours and were often illustrated. The Hours of the Virgin, too, was sometimes illustrated by scenes from the Passion. There were also more personal prayers that commemorated Christ's redemptive sufferings. For example, this delicate painting of the Man of Sorrows illustrates a prayer to Christ Crucified in a book of hours which was probably made in Cologne in the mid-fifteenth century.

The image of Christ, who shows the wounds and the ravages of the Crucifixion, yet is alive, confronts the viewer from the tomb. Silhouetted against the cross, he is surrounded by an array of objects and truncated forms that powerfully call to mind the torments of the Passion. The column of the scourging with whip entwined, a striking fist

and spitting mouth, and a hand that holds a fistful of the Saviour's hair are displayed along with more traditional instruments of the Passion, such as the lance that points provocatively at the wound already made in Christ's side and the spear that bears the vinegar-soaked sponge. In the foreground lie nails, hammer and pincers.

The instruments of the Passion are often called the 'arma Christi', with 'arms' signifying both weapons and heraldic insignia. From as early as the twelfth century they appear as attributes of Christ in scenes of the Last Judgement — a sign of his victory over sin and evil. The use of the cross in this context is much older, going back to the Early Christian era of Constantine. Devotion to the Passion and to objects or relics associated with it increased significantly in the west after renewed contact with the Byzantine world during the Crusades; and the use of the 'arma Christi' subsequently expanded into depictions that brought to mind the stages of the Passion by relating them to specific objects or abbreviated signs of violence. This composition thus combines the representation of Christ the Man of Sorrows with the expanded theme of the 'arma Christi'. The rendering of the painting in a blend of colour and light wash, and the subtle modelling of the Saviour's face and body, increase the emotional impact of the image, which, in harmony with the popular mysticism of the time, communicates both the pathos of Christ's sufferings and his final victory.

Manion, Vines and de Hamel, 1989, No. 48; V.F. Vines in *Gold and Vellum*, 1989, No. 15

49. THE TRUE ICON, CHRIST, SAVIOUR OF THE WORLD

Book of Hours, Latin

Ghent?, *c*.1490

Parchment, 8.7 x 5.6 cm 191 leaves

State Library of New South Wales, Mitchell 1/7b, fols 11v–12r

The prayer, 'Salve sancta facies' (Hail holy face — of our redeemer) is introduced in this Flemish book of hours with the rubric 'Salutation to the true Icon'. To gain the generous indulgences associated with this prayer, the devotee was required to recite it before an image of Christ, based on the imprint believed to have been left on the veil of Veronica as she wiped the Saviour's face on his way to the Crucifixion. The accompanying painting (fol. 11v) is thus required by the text. It is one of many versions produced in the workshop of Alexander Bening, who was active in Ghent *c*.1469–1519. By contrast to the image of the Man of Sorrows in No. 48, the painting depicts the Saviour as the calm majestic ruler of all, with his right hand raised in the gesture of blessing and, in his left, a crystal orb, symbol of cosmic power. In this respect,

its ancestry is as much the Christ of Majesty enthroned in the apse of Early Christian churches, as the image on the veil of Veronica. Understandably, this composition is also known under the title, Salvator Mundi, Saviour of the World.

Manion and Vines, 1984, No. 57

50. ST NICHOLAS

Prayer Book, Latin and Middle Netherlandish
Northern Netherlands, *c.*1510–25
Parchment, 15.6 x 9.6 cm 70 leaves
Ballarat Fine Art Gallery, MS Crouch 12, fol. 30v

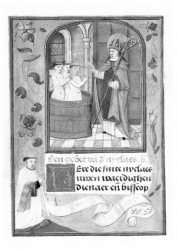

The Church calendar commemorates the saints of every age, as well as the events of Christ's life, and the use of Gospel texts and other passages from the Scriptures for their Mass and offices expresses the continuity of salvation history and the expansion of the Gospel throughout time and place. Often, and to an extraordinary degree, the lives and deeds of the saints are embellished with fantasy and legend; and in many cases, they are to be interpreted as embodying certain Christian ideals rather than historical fact. In particular they reflect the communal nature of Christianity and they held an important place in medieval devotion. In this book, which contains prayers written in Middle Netherlandish or medieval Dutch, the saints honoured include St Nicholas, the bishop around whom the legend of Santa Claus developed (first in Holland) on account of his fabled generosity and concern for children and young people. The miniature which accompanies the prayer to St Nicholas illustrates a famous miracle in which the saint brought back to life three youths whom a wicked butcher had pickled in brine. The resplendent appearance of Nicholas in full episcopal regalia adds a touch of authority to this improbable story and the kneeling cleric in the border invites the reader to join with him in prayer to this great servant of the Lord.

The border of this miniature, with flowers strewn illusionistically over its gold surface is characteristic of late Netherlandish work, and the book has been associated with a group of manuscripts illuminated in Leiden. Arms and insignia on a number of the pages, and the singling out, in the calendar and in the book's illumination, of the Flemish saint, William of Maleval, and St Margaret, indicate that it was made for a couple whose names were William and Margaret.

Manion and Vines, 1984, No. 61; V.F. Vines in *Gold and Vellum*, 1989, No. 26

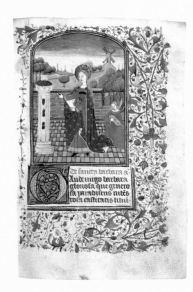

51. ST BARBARA

Book of Hours, Use of Sarum, Latin
Southern Netherlands (Bruges?), *c*.1450–70
Parchment, 19.5 x 14.0 cm 126 leaves
National Library of Australia, Clifford Collection, MS 1097/9 fol. 23r

Barbara was one of the most popular female saints of the Middle Ages. In this fifteenth-century book of hours, made probably in Bruges for export to an English patron, she is readily recognisable by her attribute, the tower towards which she gestures. According to legend, Barbara lived in the third century, and she was imprisoned in a tower by her father to protect her against undesirable suitors and Christian influences. She was, however, converted to Christianity and the three windows in the tower wall reflect the effects of this, since she is said to have persuaded the builders to increase the number of windows to three in honour of the Trinity. Barbara holds a book, symbol of the prayer and study that led to her conversion. The attendant music-making angel indicates that she is now in Paradise, as the introductory antiphon to the accompanying prayer states.

Barbara was martyred for her faith, being decapitated by her father who was then struck by lightning. Somewhat paradoxically, Barbara was customarily invoked against the dangers of lightning. As well as being a strong female role model, she was the patron of builders and architects, because of her involvement with the tower windows; and, by extension of her connection with lightning, she was also patron of miners and gunners.

Manion and Vines, 1984, No. 54; V.F. Vines in *Gold and Vellum*, 1989, No. 14

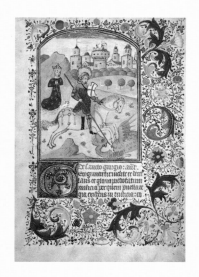

52. ST GEORGE

Book of Hours, Use of Sarum, Latin
Southern Netherlands (Bruges?), *c*.1450–70
Parchment, 23.4 x 16.7 cm 109 leaves
Auckland Central City Library, Special Collections, Med. MS G.146, p. 31

The warrior saint known as St George is said to have come from Palestine and to have been martyred there in the late third or early fourth century. He was venerated in the east from very early times; and, although he was known in England from about the eighth century, it was largely through the Crusades that St George became popular in the west. He was named patron of the Order of the Garter, when it was founded by Edward III, *c*.1348, and it may have been at that time that he became the patron saint of England. The best known story of St George is his rescue of a princess from the dragon which was threatening the countryside, and to whom the maiden was to be sacrificed.

This legend, which is medieval in origin, is a clear expression of the chivalric ideal. It is simply, yet effectively depicted in an illustration to the prayer in honour of St George in this book of hours made probably in Bruges for a Scottish patron, who may have been Sir John Colquhoun, Great Chamberlain of Scotland. The red cross which the saint wears on his shield indicates his crusading zeal, and his battle with the dragon is not unlike depictions of the archangel Michael fighting the devil. While the mythological elements in the story of St George are abundantly clear, so too is the fact that he stands for Christian courage in the fight against the forces of evil.

Manion, Vines and de Hamel, 1989, No. 25

53. ST JOHN THE EVANGELIST AND THE POISONED CUP

Book of Hours (fragment), Latin and French

Eastern France (Dijon?), *c.*1430–40

Parchment, 19.5 x 14.0 cm 96 leaves

State Library of Victoria, *096/R66 Hm, fol. 13r

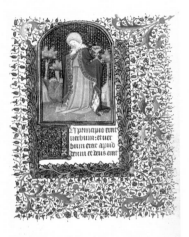

Alongside the prayers and images of the saints, with their tangled threads of myth and history, the book of hours often contained a series of passages from the four Gospels. These comprised the Mass readings for the feasts of Christmas (John 1. 1–14), the Annunciation (Luke 1. 26–38), the Epiphany (Matthew 2. 1–12) and the Ascension (Mark 16. 14–20). The selection virtually covers the life of Christ, commemorated in the seasons of the Church year, with the exception of the Passion. Some books also contained a separate extract from the account of the Passion by St John. In keeping with ancient tradition, the four Gospel extracts were usually introduced by evangelist portraits or, as in the case of this particular book of hours, by a single portrait of St John whose prologue begins the series. This miniature refers to an event in the legendary account of the life of the saint. Although the usual apocalyptic symbol of the eagle accompanies him, John holds, instead of his customary book, a chalice with snakes issuing from it. According to the legend, the apostle was challenged by Aristodemus, priest of the cult of the goddess Diana, to drink a poisoned cup as a test of the power and authenticity of the God that he professed. John blessed the cup and then drank the poison with no ill effects. Although this account is apocryphal, it relates, as does its pictorial representation, to the passage in Mark (16. 17–18), where Christ lists the signs that will distinguish those who proclaim the Gospel: 'These are the signs that will be associated with believers: in my name they will cast out devils; they will have the gift of tongues; they will pick up snakes in their hands, and be unharmed should they drink deadly poison; they will lay their hands on the sick, who will recover.'

This manuscript, now in a fragmentary state, no longer contains the Hours of the Virgin or other devotions apart from the Penitential Psalms, the Litany of the Saints and the Office of the Dead. Its calendar is based on a Parisian model, but the litany includes saints venerated in Dijon and Besançon. Later notes record that it belonged to the Canon of the Sainte Chapelle at Dijon in the sixteenth century and, in 1600, came into the possession of the king's counsellor, Pierre Maresech, who was responsible for overseeing the collection of taxes in Burgundy. The book's illumination is also indicative of high quality work in eastern France in the 1430s–40s which incorporates elements from earlier Parisian illumination.

Manion and Vines, 1984, No. 74; V.F. Vines in *Gold and Vellum*, 1989, No. 13; Hubber, 1993, 6

54. ST LUKE

Book of Hours, Latin and French
Bourges, *c*.1480
Parchment, 17.0 x 9.0 cm 115 leaves
State Library of New South Wales, Mitchell 1/7c, fol. 11r

Each of the four extracts from the Gospels in this book of hours is introduced by a portrait of the appropriate evangelist. In this miniature St Luke is shown at work in his study in the company of his symbol the ox. Depicted on the wall behind him is the Annunciation, the subject of his text. This manuscript was illuminated by an assistant of Jean Colombe, who was the head of a productive workshop in Bourges in the late fifteenth century. Colombe executed large and innovative programs for both secular and religious books commissioned by distinguished noble patrons, as well as supplying the needs of the lesser nobility and wealthy residents of Bourges. He completed, for example, the *Très Riches Heures* for Charles of Savoy, the famous book of hours which originally belonged to Jean de Berry, and whose illumination was largely carried out by the Limbourg Brothers (*c*.1411–16). His book of hours for Louis de Laval contains one of the most extensive illustrative programs ever undertaken for a book of hours, consisting of well over a thousand miniatures. Colombe devised many new compositions that reveal a sound knowledge of the relevant texts, as well as an interest in dramatic narrative and naturalistic detail. The projection onto the wall behind the evangelists of the subject of their writing is an example of this, and appears in several of the books illuminated by Colombe or his assistants.

Manion and Vines, 1984, No. 80

55. ST LUKE

Book of Hours, Latin and French
Paris, *c*.1490–1500
Parchment, 16.3 x 11.5 cm 208 leaves
Anglican Church of Australia, Diocese of Adelaide.
On loan to State Library of South Australia. fol. 15v

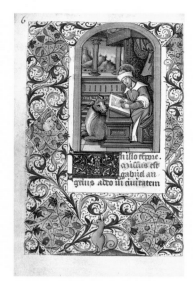

In this French book of hours, illuminated at the end of the fifteenth century, the evangelists continue to be presented in accordance with the ancient tradition of the author–scholar. Here, St Luke's status as a writer is enhanced by his spacious surrounds, and the canopy over his seat is embroidered with the title of his Gospel. With the sleeves of his outer garment rolled back, the evangelist writes busily, while his symbol the ox turns towards him, more like a companionable dog than a source of inspiration.

In its own way, this illustration performs the same basic function as the evangelist portraits and symbols in the Book of Kells. It authenticates the Gospel text by reference to the evangelist and his link with apostolic tradition. Still discernible, too, is Luke's association with the time-honoured animal symbol, although there is no indication here of its apocalyptic origins. The miniature thus highlights the paramount importance of the text itself and the fact that the owner of this book of hours had personal access to significant extracts of the authentic Gospels.

Manion and Vines, 1984, No. 79; V.F. Vines in *Gold and Vellum*, 1989, No. 22

Note: The English translations of biblical texts in this catalogue are taken from *The Jerusalem Bible*, London: Darton, Longman and Todd, 1966

The pioneering work of the late Keith Val Sinclair, *Descriptive Catalogue of Medieval and Renaissance Western Manuscripts in Australia*, Sydney: Sydney University Press, 1969, is gratefully acknowledged. His research on individual manuscripts is cited in the catalogue entries in Manion and Vines, 1984. I also acknowledge with deep appreciation the work of my colleagues Vera F. Vines and Christopher de Hamel (Manion and Vines, 1984; and Manion, Vines and de Hamel, 1989). (M.M.)

Glossary

ANTIPHONAL — A CHOIR BOOK with the music and chants for the DIVINE OFFICE.

BOOK OF HOURS — A prayer book popular with the laity in the later Middle Ages. It usually contains a calendar and short offices or hours, especially the Hours of the Virgin, the Hours of the Cross or Passion, the Hours of the Holy Spirit and the Office or Vigils of the Dead. Other supplementary devotions from the BREVIARY, for example the Penitential Psalms, the Litany of the Saints, and suffrages or petitions to the saints, are also frequently included, as well as extracts from the four Gospels and a selection of personal prayers.

BREVIARY — The book containing the texts for the celebration of the DIVINE OFFICE.

CANONICAL HOURS — The name given to the particular times of the day — matins, lauds, prime, terce, sext, none, vespers and compline dedicated to the celebration of the DIVINE OFFICE

CANON TABLES — Comparative tables or concordances of the common subject matter in the four Gospels. These tables, which date from the fourth century usually appear at the beginning of Gospel books.

CHOIR BOOK — A book with the music and chants to be sung by the choir in church services

CHURCH YEAR — The division of the year into two parallel cycles of feasts. The temporal cycle celebrates the life of Christ and the foundation of the Church, from the Annunciation to Pentecost. The sanctoral cycle celebrates the saints.

CODEX — The name given to a book made of a series of folded sheets stitched along one side. It appeared in the first century and by the fourth century had replaced the roll as the favoured shape of the book. The codex persisted as the format of the printed book.

DECRETALS — Collections of papal letters, used in the study of church or canon law.

DIVINE OFFICE — The public prayer of the Church performed at the CANONICAL HOURS of the day by clerics and many religious orders. It is based on the weekly recitation of the PSALTER, with readings from the Scriptures and commentaries, together with hymns, antiphons, versicles and responsories that accentuate the theme of the particular feast of the CHURCH YEAR.

FOLIO — A leaf or sheet in a manuscript. Manuscripts are usually numbered by folios rather than pages. The upper side of a folio, or the right-hand side of a double-page opening, is called the recto (r); the reverse side of a folio, or the left-hand side of an opening, is called the verso (v) — eg, the folio numbers of an opening will appear as 3v–4r. Folio is often abbreviated to f. or fol.

GOSPEL BOOK — book containing the four Gospels, usually introduced by CANON TABLES, prefaces and summaries.

GRADUAL — A CHOIR BOOK with the music and chants for the MASS or Eucharist.

HOURS OF THE VIRGIN — A short office in honour of the Virgin, based on the CANONICAL HOURS. It was very popular with the laity in the later Middle Ages and regularly featured in BOOKS OF HOURS.

LITURGY — The public worship of the Church. Two of its principal components are the MASS and the DIVINE OFFICE.

MASS — The church service which commemorates the redemptive life, death and Resurrection of Christ. It is also called the Eucharist, from the Greek word 'thanksgiving'.

MINIATURE — An independent picture in a manuscript — the term derives from the red pigment 'minium', and does not in this context refer to size.

MISSAL — The book containing all the texts for the celebration of the Mass

PONTIFICAL — The book containing the rituals and blessings performed by a bishop.

PSALMS — Songs in the Old Testament commonly attributed to King David, although he did not write them all. The psalms were adopted by the Church as the basis for Christian prayer.

PSALTER — The book containing the 150 psalms and certain canticles from the Old and New Testaments.

PSALTER-HOURS — A book containing the psalter and selected offices or hours from the BREVIARY, especially the HOURS OF THE VIRGIN. It is the forerunner of the BOOK OF HOURS.

RUBRIC — Instructions, comments and titles that help organise the contents of a book or indicate how a ceremony described in it is to be performed. Rubrics are often written in red, and the name comes from *rubrica* –'red'.

Bibliography

The Book of Kells

Meehan, Bernard, *The Book of Kells: An Illustrated Introduction to the Manuscript in Trinity College Dublin*, London: Thames and Hudson, 1994.

Meehan, Bernard, *The Book of Durrow: A Medieval Masterpiece at Trinity College Dublin,* Dublin: Town House and Country House, Colorado: Roberts Rinehart, 1996.

O'Mahony, Felicity (ed.), *The Book of Kells: Proceedings of a Conference at Trinity College Dublin, 6–9 September 1992,* Aldershot: Scolar Press, for Trinity College Library, 1994, and the bibliography provided there.

The Art of Illumination

Alexander, J.J. (ed.), *The Painted Page: Italian Renaissance Book Illumination 1450–1550*, London and Munich: Royal Academy of Arts and Prestel Verlag, 1994.

Avril, F. and N. Reynaud, *Les Manuscrits à Peintures en France, 1440–1520,* Paris: Flammarion-Bibliothèque Nationale, 1993.

Dauner, G., 'Ein neuer zeitlicher Fixpunkt für Neri da Rimini', *Kunstchronik*, no. 48, 1995, 445–446.

Dauner, G., 'Cantami, codice, di Neri la Storia', *Il Ponte*, Rimini (26 May 1996), 8–9.

De Hamel, C., *A History of Illuminated Manuscripts,* London: Phaidon, (2nd edn rev.) 1994

Garzelli, A. and A.C. de la Mare, *Miniatura fiorentina del rinascimento 1440–1525: Un primo censimento,* 2 vols, Florence: Scandicci, 1985.

Hubber, B., '"Of the Numerous Opportunities": The Origins of the Collection of Medieval Manuscripts at the State Library of Victoria', *La Trobe Library Journal,* vol. 13, nos 51 and 52, (1993), 3–11.

Manion, M.M. and V.F. Vines, *Medieval and Renaissance Illuminated Manuscripts in Australian Collections*, London: Thames and Hudson, 1984.

Manion, M.M., V.F. Vines and C. de Hamel, *Medieval and Renaissance Manuscripts in New Zealand Collections*, London: Thames and Hudson, 1989.

Manion, M.M., L. Knowles and J. Payne, 'The Aspremont Psalter-Hours: The Making of a Manuscript', *The Art Bulletin of Victoria*, no. 34, (1994), 25–34.

Melbourne, the University of Melbourne Museum of Art. Ian Potter Gallery, *Gold and Vellum*, Melbourne, 1989.

Michael, M. and N. J. Morgan, 'The Sarum Breviary in the Baillieu and Bodleian Libraries', *La Trobe Library Journal*, vol. 13, nos 51 and 52 (1993), 32–37.

Monks, P. R., *Patrons and Devotion: The University of Sydney's Hours of Anne la Routye,* Sydney: University of Sydney Library, 1995.

Muir, B.J. and A. J. Turner, *Vita Sancti Wilfridi Auctore Edmero. The Life of Saint Wilfrid by Edmer*, Exeter: University of Exeter Press, 1998.

Naughton, J., 'The Poissy Antiphonary in its Royal Monastic Milieu', *La Trobe Library Journal*, vol. 13, nos 51 and 52 (1993), 38–49.

Naughton, J., *Manuscripts from the Dominican Monastery of Saint-Louis de Poissy*, 2 vols, PhD Dissertation, The University of Melbourne, 1995.

Naughton, J., 'Books for a Dominican Nuns' Choir: Illustrated Liturgical Manuscripts at Saint-Louis de Poissy, *c.*1330-1350', in M.M. Manion and B.J. Muir (eds), *The Art of the Book*, Exeter: Exeter University Press, 1998, 67–110.

O'Brien, C., 'Lorenzo's Book: A Medicean Manuscript of the Augustan History', *La Trobe Library Journal*, vol. 13, nos 51 and 52 (1993), 72–78.

Oliver, J. 'Devotional Images and Pious Practices in a Psalter from Liège', *La Trobe Library Journal*, vol. 13, nos 51 and 52 (1993), 24–29.

Oliver, J., *Gothic Manuscript Illumination in the Diocese of Liège (c.1250–1330)*, 2 vols, Louvain: Uitgeverij Peeters, 1988.

Rimini, Museo della Città, *Neri da Rimini*, Milan: Electa, 1995.

Schapiro, M., 'The Image of the Disappearing Christ', in *Late Antique, Early Christian and Medieval Art, Selected Papers*, New York: George Braziller Inc., 1979, 266–287.

Sinclair, K.V., *Descriptive Catalogue of Medieval and Renaissance Western Manuscripts in Australia:*, Sydney: Sydney University Press, 1969.

Spier, J. and G. Morrison, *San Marco and Venice*, Melbourne: National Gallery of Victoria, 1997.

Stinson, J., 'The Poissy Antiphonal: A Major Source of Late Medieval Chant', *La Trobe Library Journal*, vol. 13, nos 51 and 52 (1993), 50–59.

Stocks, B.C., *Text and Decoration in the Early Italian Book of Hours*, PhD Dissertation, The University of Melbourne, 1998.

Stocks, B.C., 'The Illustrated Office of the Passion in Italian Books of Hours', in M.M.Manion and B.J. Muir (eds), *The Art of the Book*, Exeter: Exeter University Press, 1998, 111–152.

Tonkin, J., *The Glorious Antiphonal*, Adelaide: Friends of the Sate Library of South Australia, 1998.

Vines, V.F., 'Reading Medieval Images: Two Miniatures in a Fifteenth-Century Missal', in M.M. Manion and B.J. Muir (eds), *Medieval Texts and Images*, Sydney: Gordon and Breach, 1991, 127–147.

Vines, V.F., '"The Daily Round, the Common Task": Three Books of Hours in the State of Victoria', *La Trobe Library Journal*, vol. 13, nos 51 and 52 (1993), 80–92.

Vines, V.F., 'A Centre for Devotional and Liturgical Manuscript Illumination in Fifteenth-Century Besançon', in M.M. Manion and B.J. Muir (eds), *The Art of the Book*, Exeter: Exeter University Press, 1998, 195–223.

Lenders to the Exhibition

Alexander Turnbull Library, National Library of New Zealand/Te Puna Mātauranga o Aotearoa, Wellington
 Cat. Nos 2, 47
Anglican Church of Australia, Diocese of Adelaide, Adelaide
 Cat. No. 55
Auckland Central City Library, Auckland, Special Collections
 Cat. Nos 14, 17, 23, 52
Ballarat Fine Art Gallery, Ballarat
 Cat. Nos 1, 5, 10, 37, 50
 Gift of Colonel the Honorable R.A. Crouch, 1944
Bible Society in New Zealand, Wellington
 Cat. Nos 7, 22, 41
Bishop's House, Ponsonby, Auckland
 Cat. No. 27
Dunedin Public Libraries, Dunedin, Alfred and Isabel Reed Collections
 Cat. Nos 20, 21, 26, 36, 46
National Gallery of Australia, Canberra
 Cat. No. 24
National Library of Australia, Canberra, Clifford Collection
 Cat. Nos 8, 38, 44, 51
National Gallery of Victoria, Melbourne
 Cat. Nos 11, 19, 35, 39, 43 (Felton Bequest, 1937, 1959, 1922, 1961, 1920)
State Library of New South Wales, Sydney
 Cat. Nos 4, 30, 49, 54
State Library of South Australia, Adelaide
 Cat. Nos 25, 45
State Library of Victoria, Melbourne
 Cat. Nos 3, 9, 12, 18, 29, 31, 32, 33, 40, 53
Trinity College Library, Dublin
 The Gospel of St Mark, Book of Kells
Trinity Methodist Theological College Collection, Kinder Library, St John's College, Auckland
 Cat. No. 48
The University of Melbourne Library, Melbourne
 Cat. No. 34
 Presented by the Friends of Baillieu Library 1973/74
University of Sydney Library, Sydney
 Cat. Nos 6, 13, 15, 16, 42
Private Collection
 Cat. No. 28

All works are reproduced in this catalogue by kind permission of the owners.

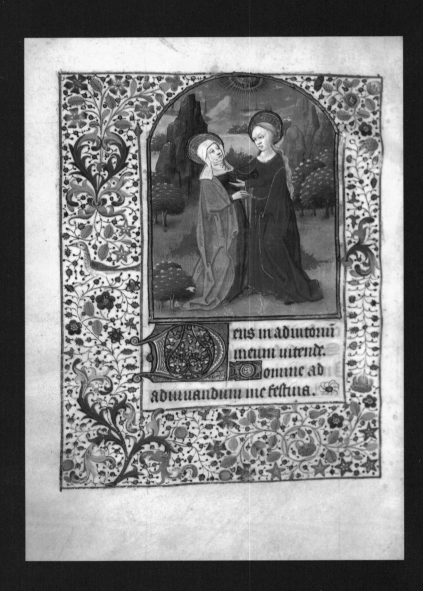

■ national gallery of **australia**